We believe sharing is caring, and we would love to see your art!

Please send us or post your lovely work of art online for all of us.

ColorMeZenBooks

Color Me Zen Books

#colormezenbooks

Find More Books at www.colormezenbooks.com

© Color Me Zen 2016 - All Rights Reserved

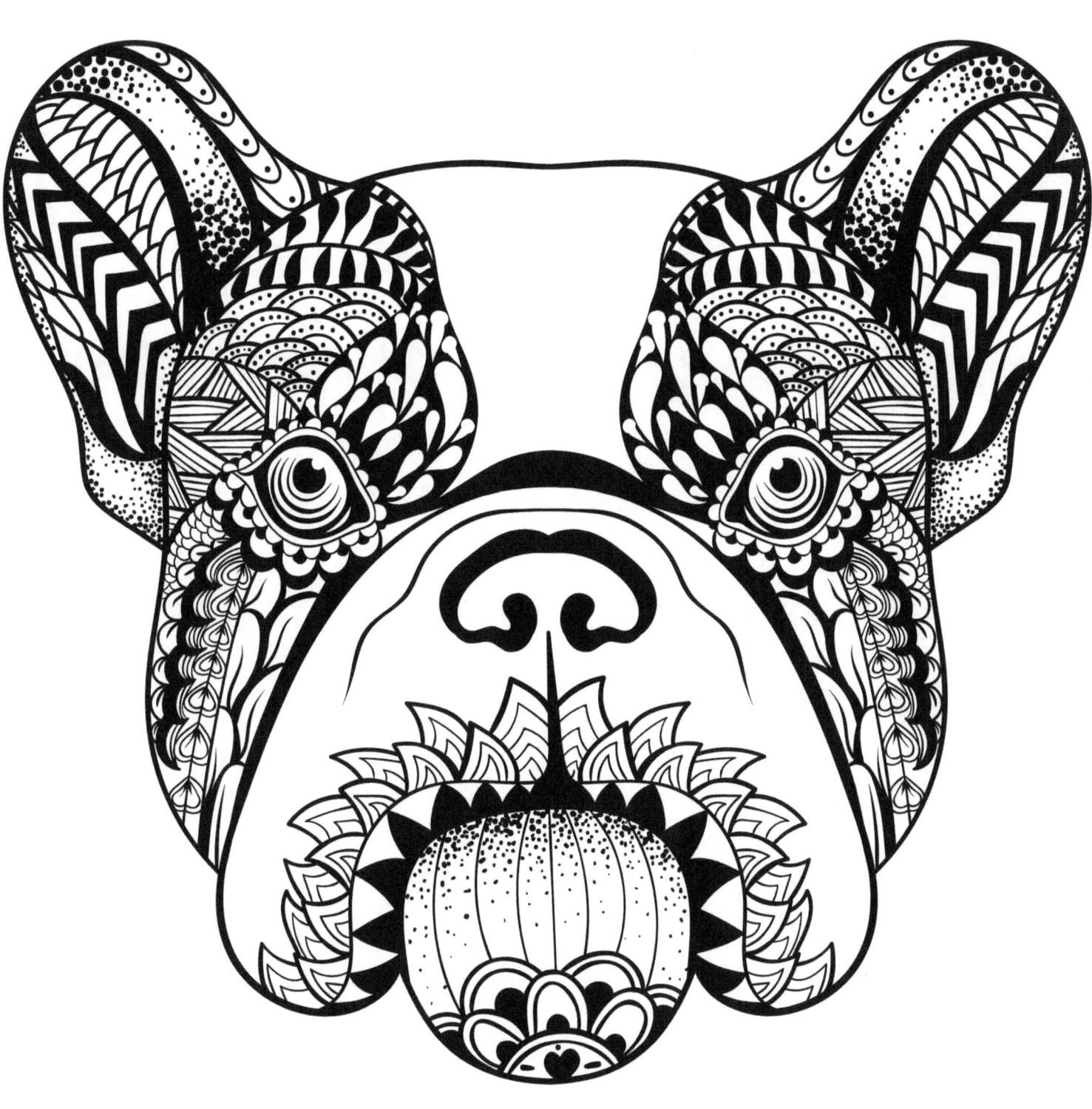

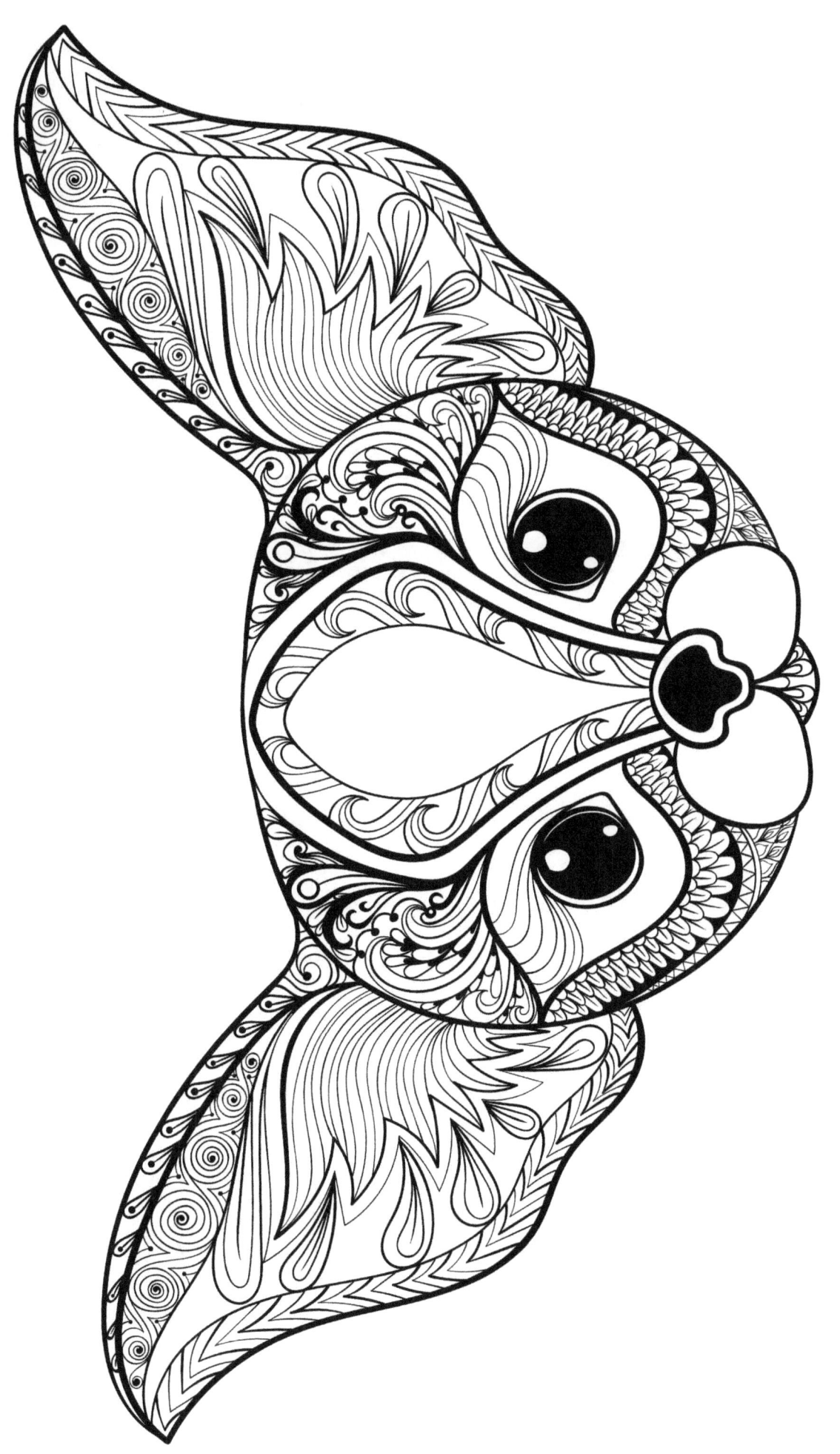

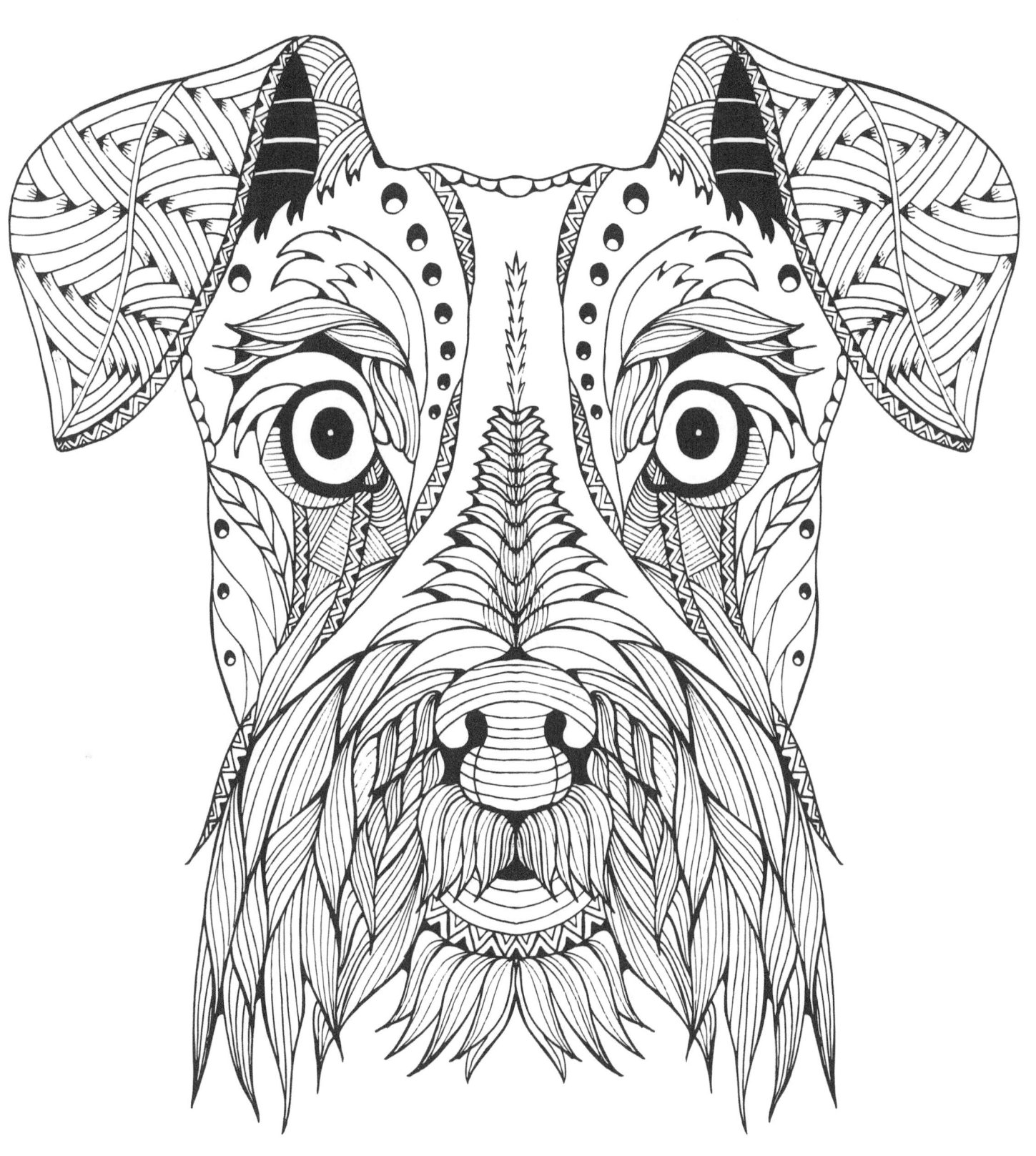

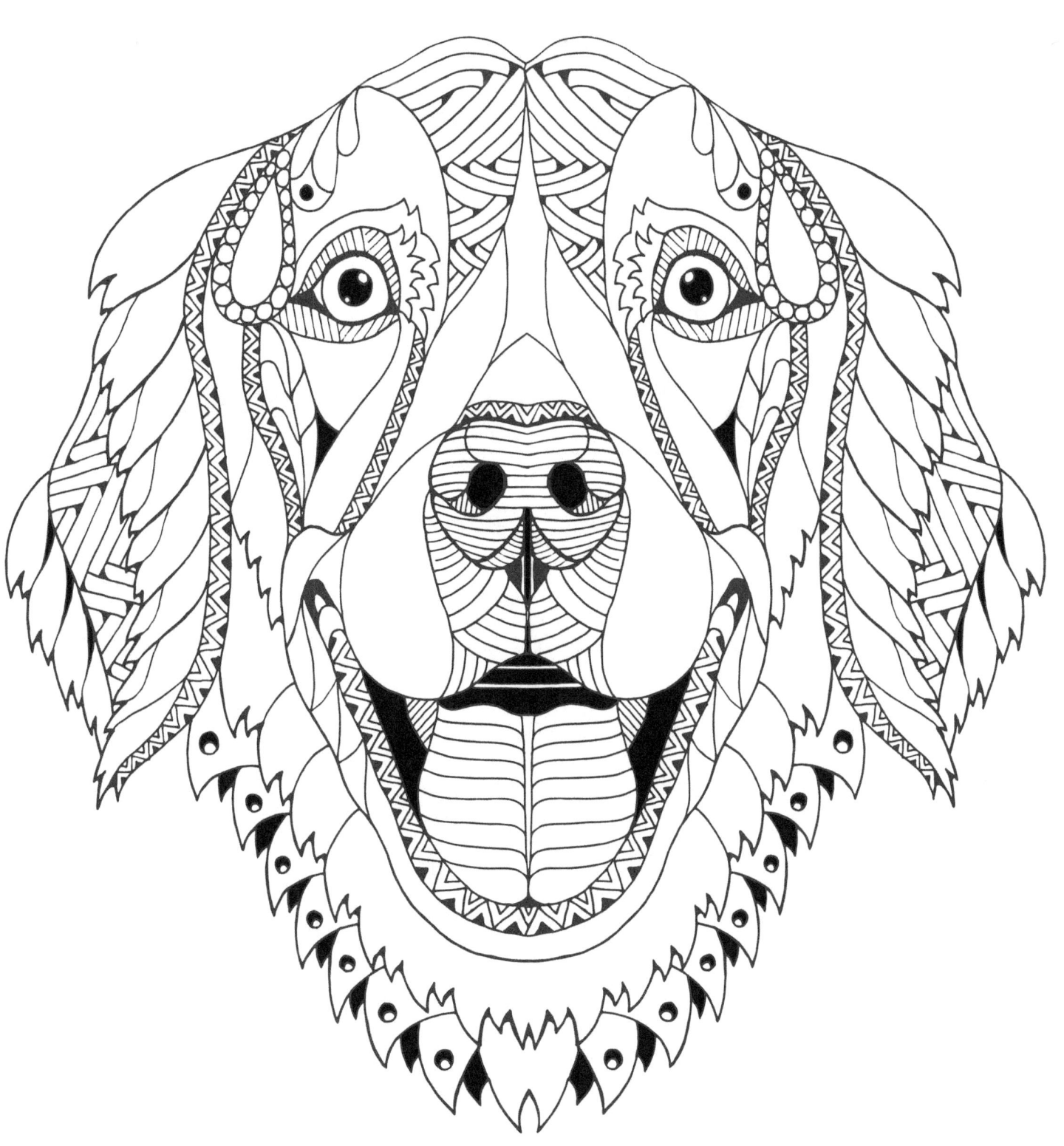

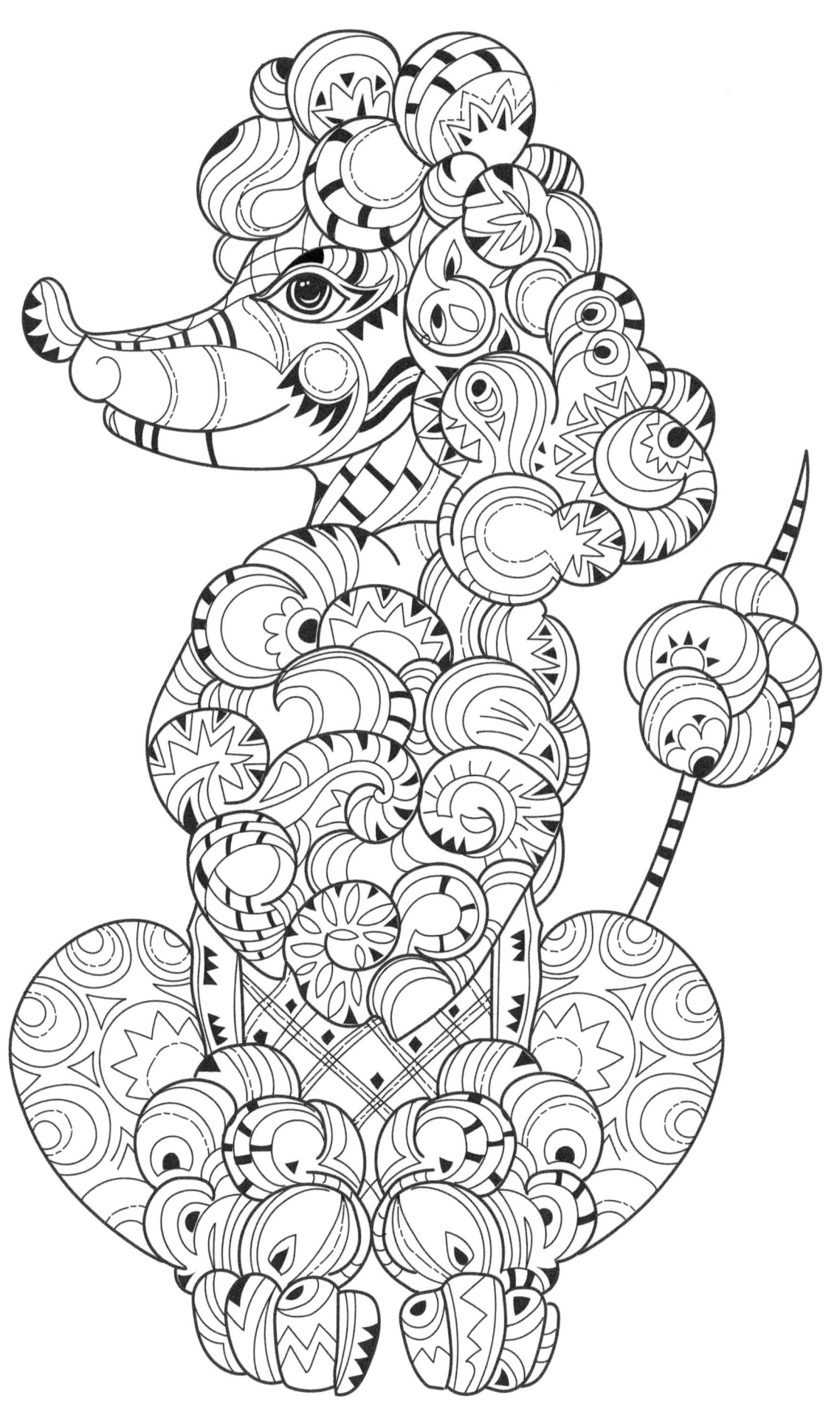

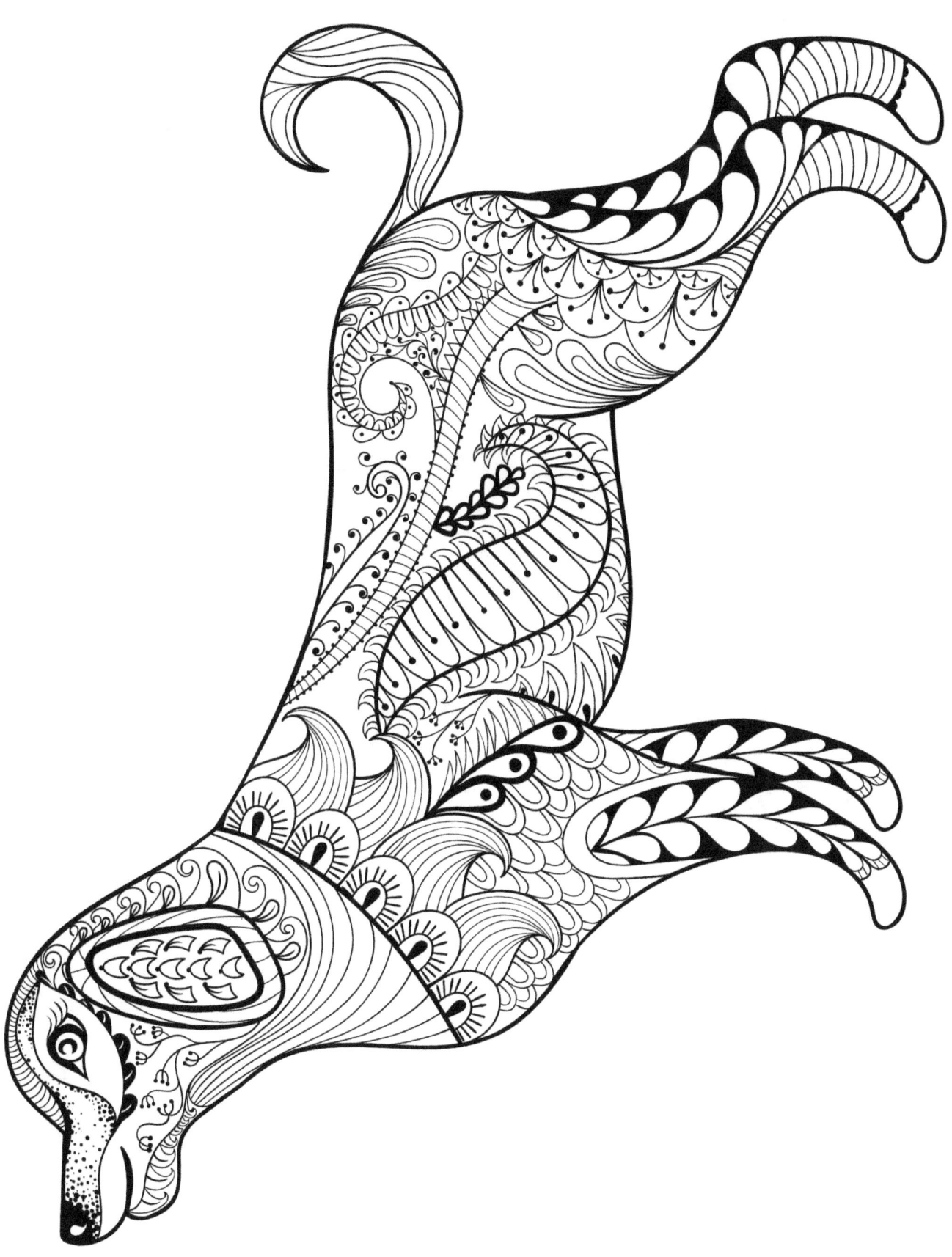

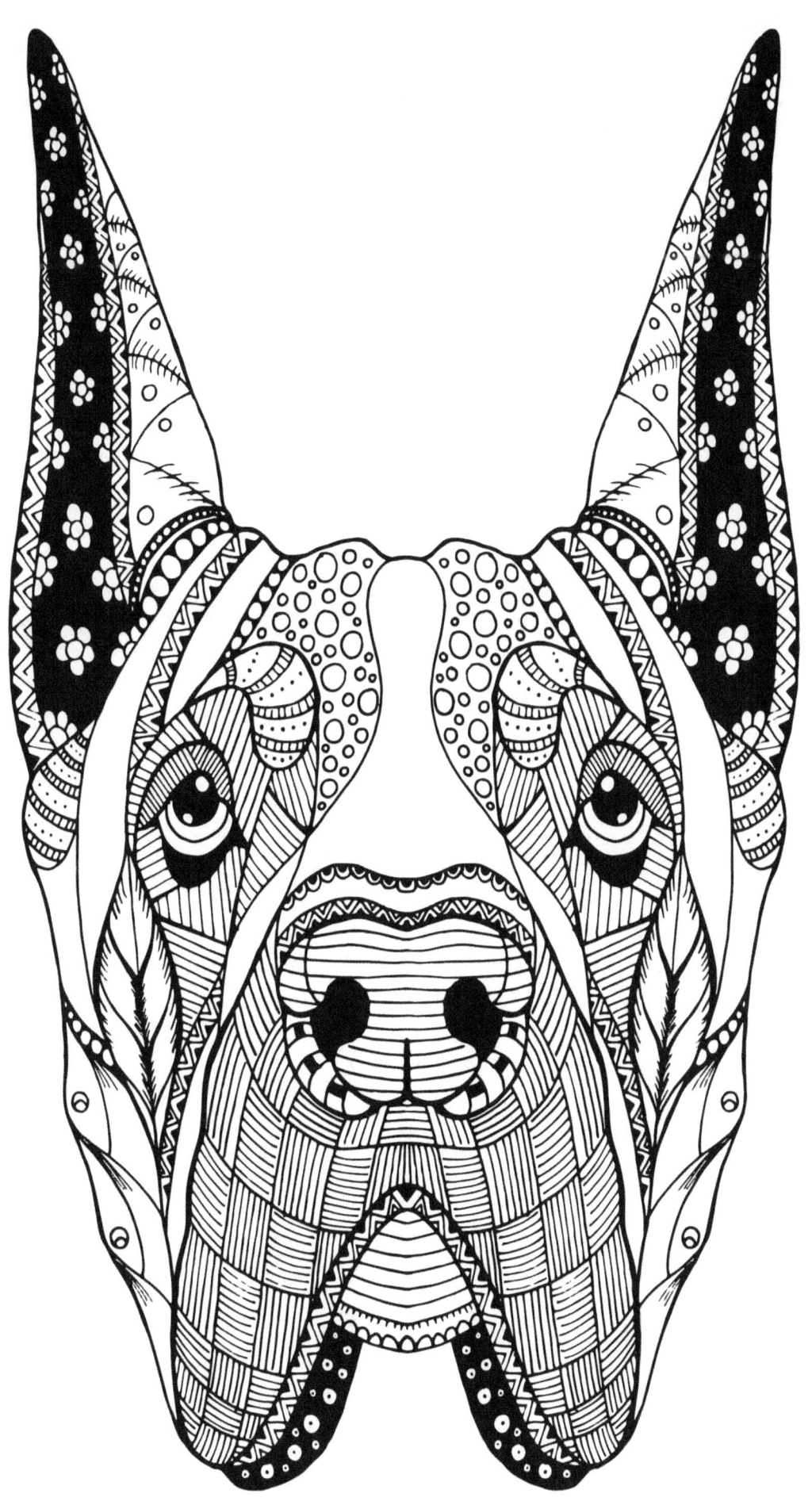

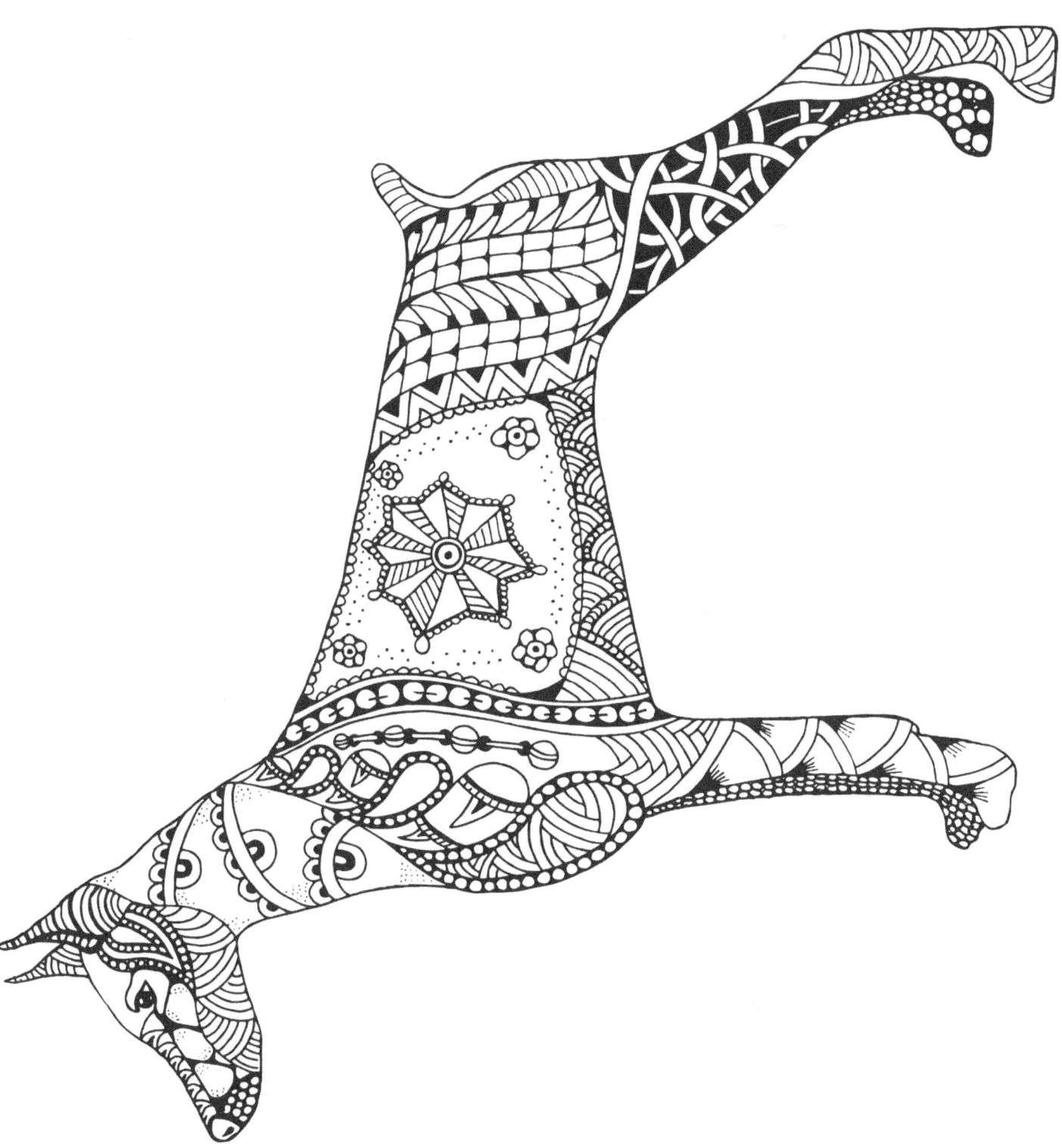

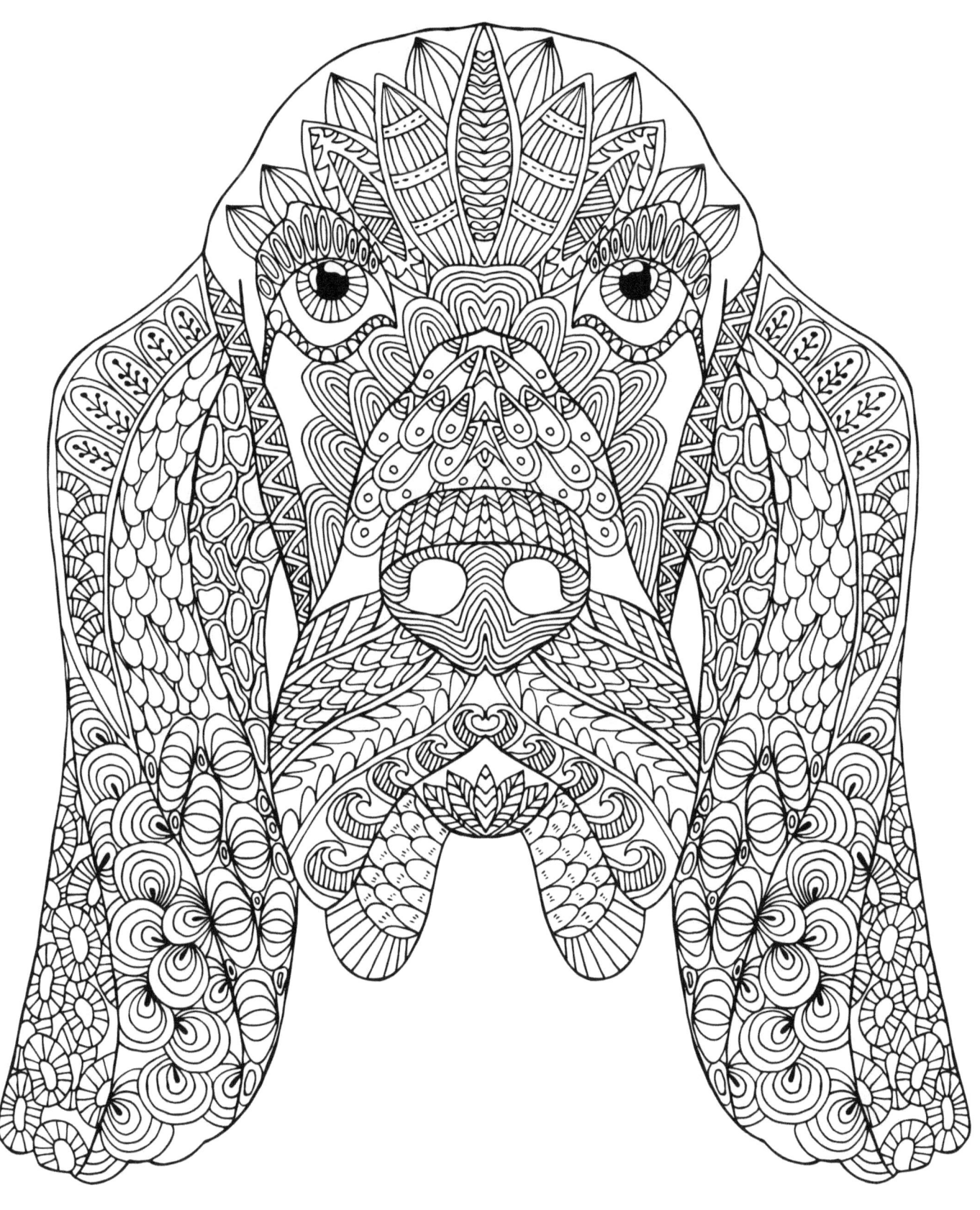

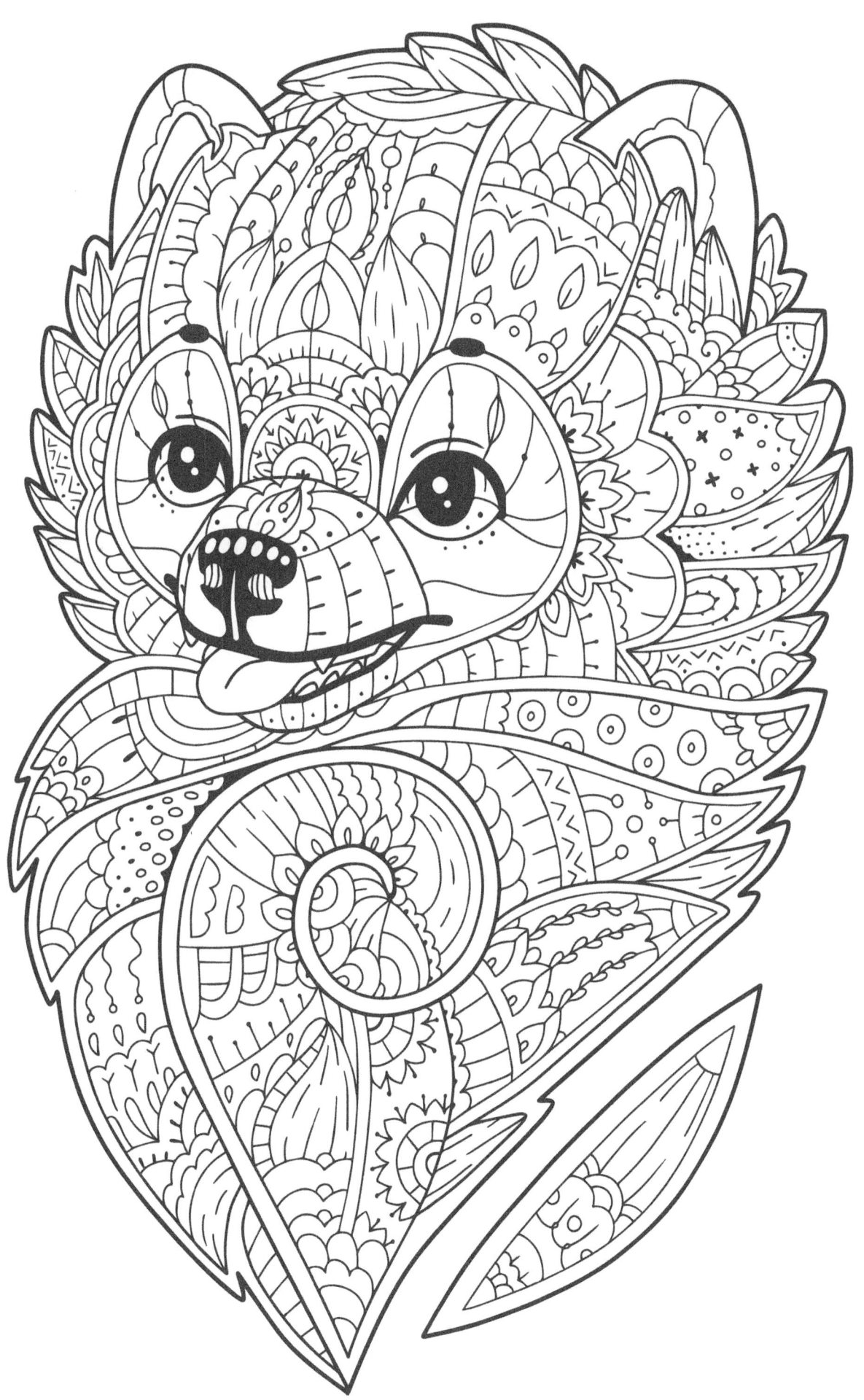

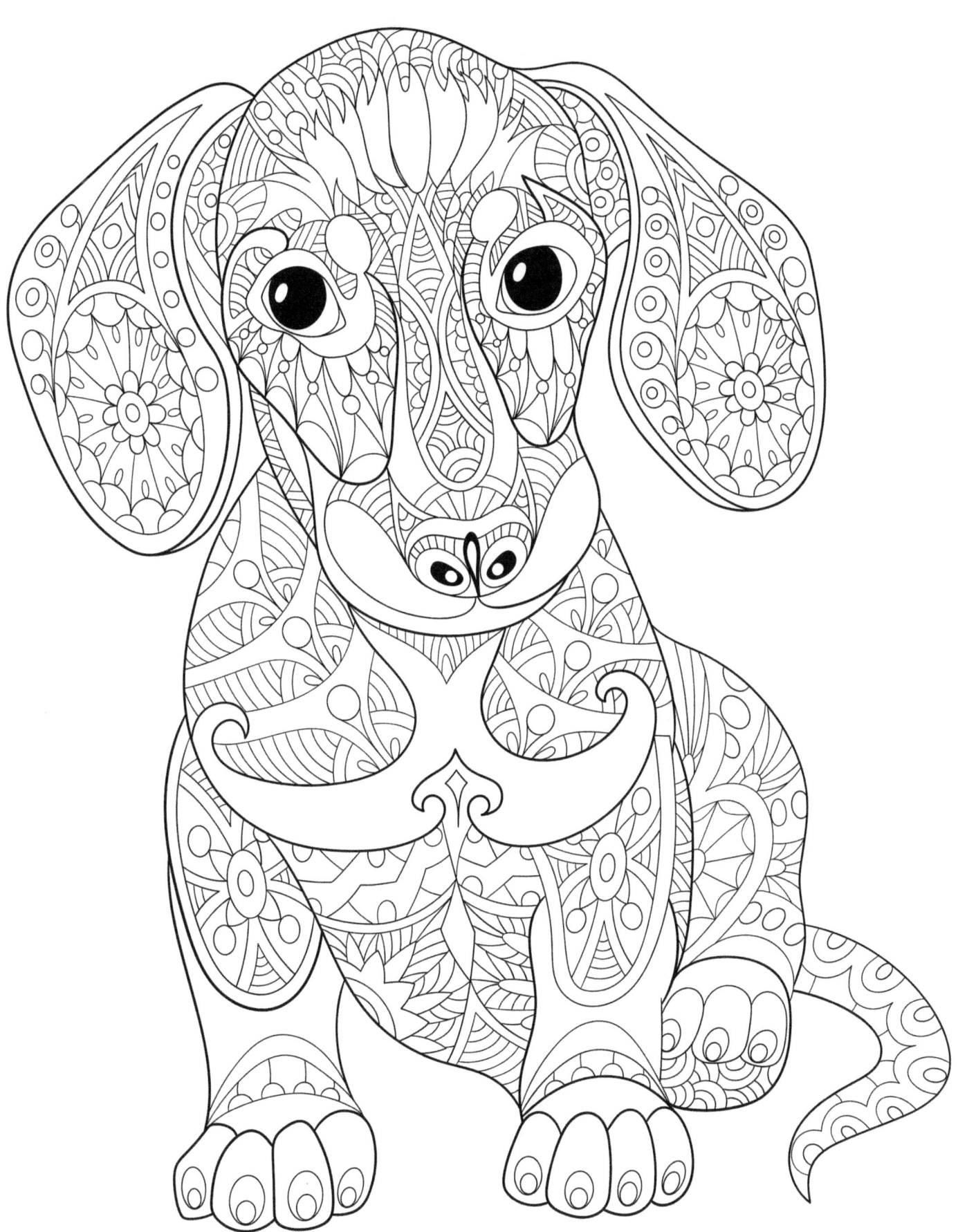

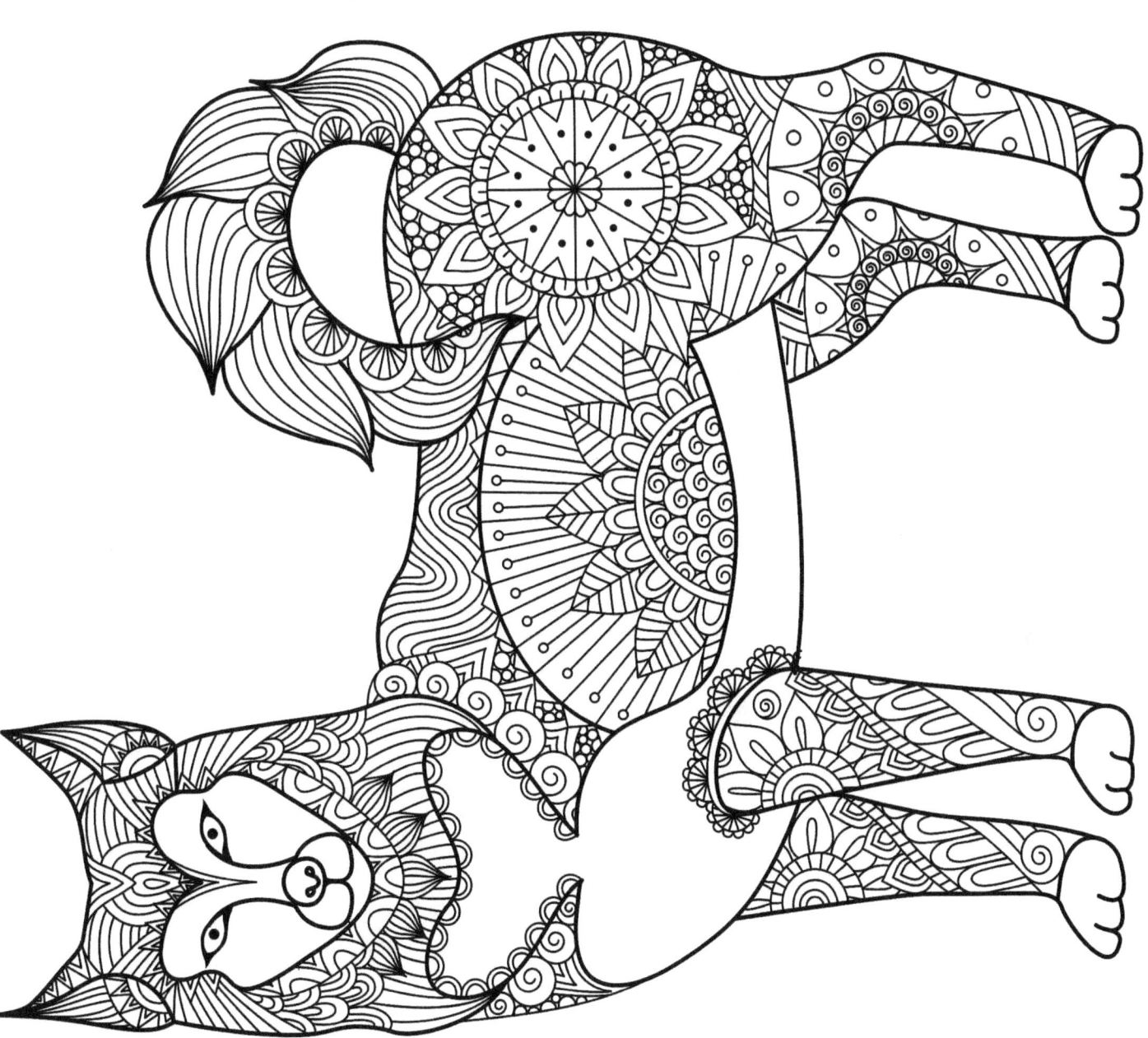

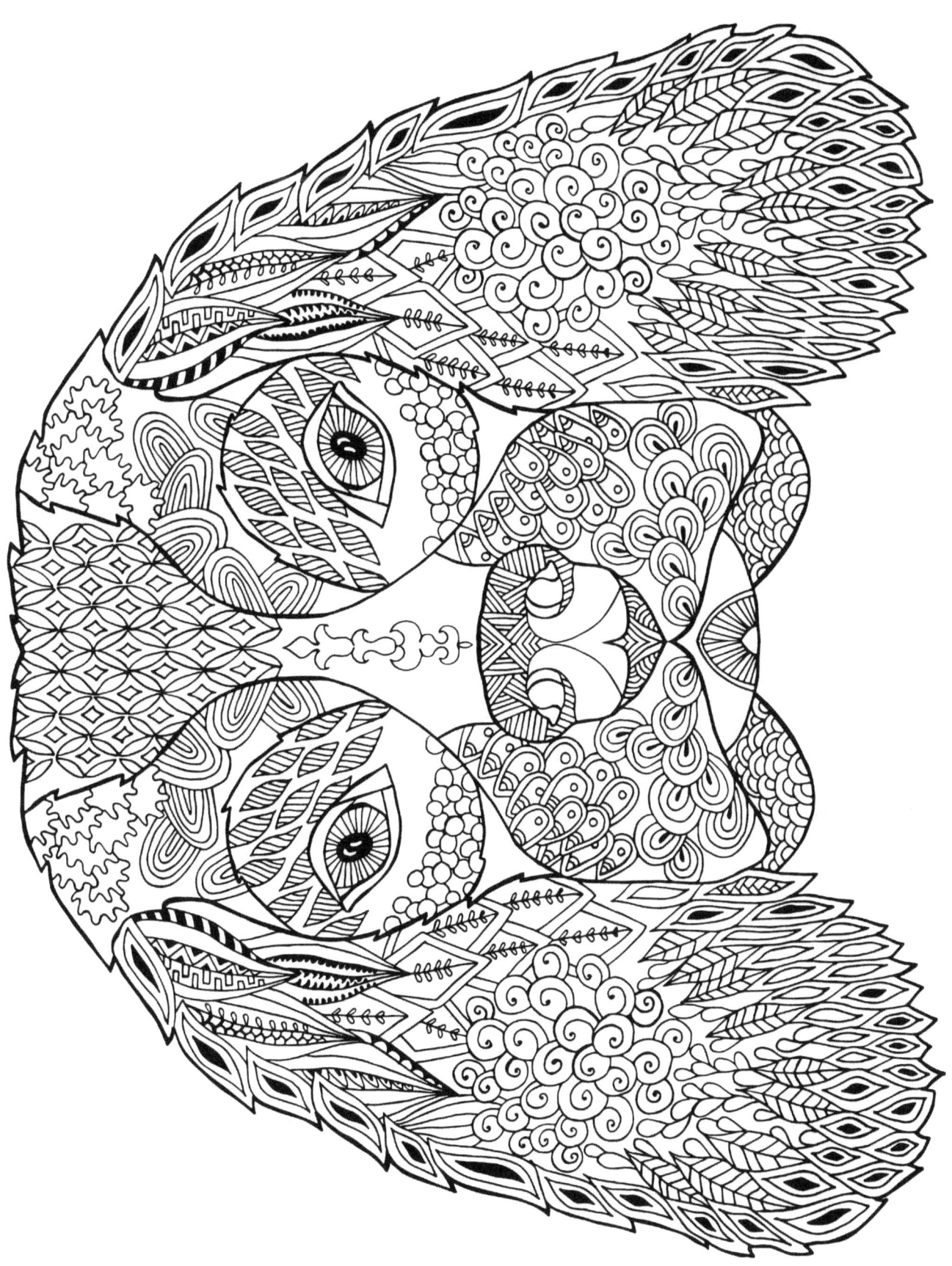

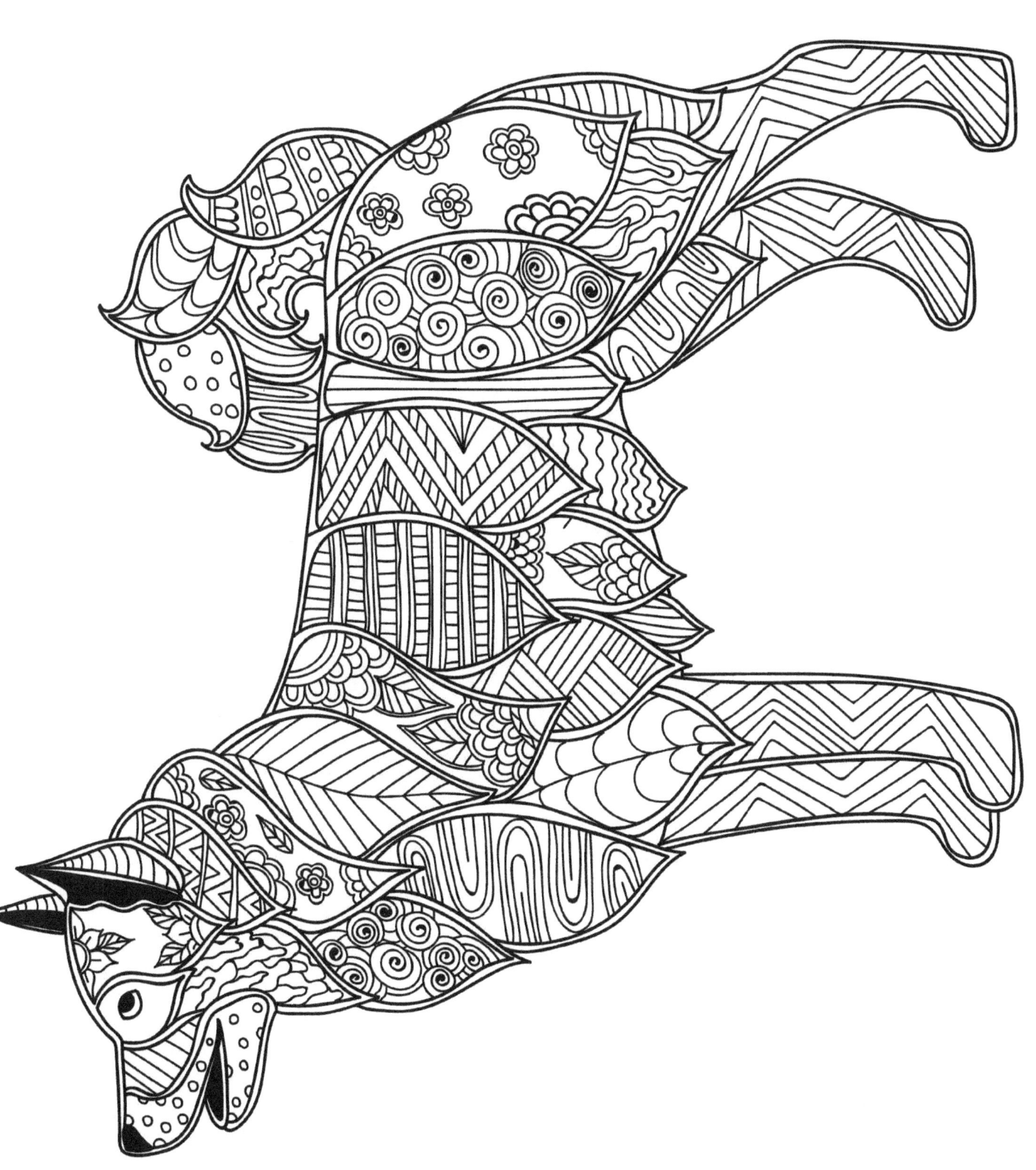

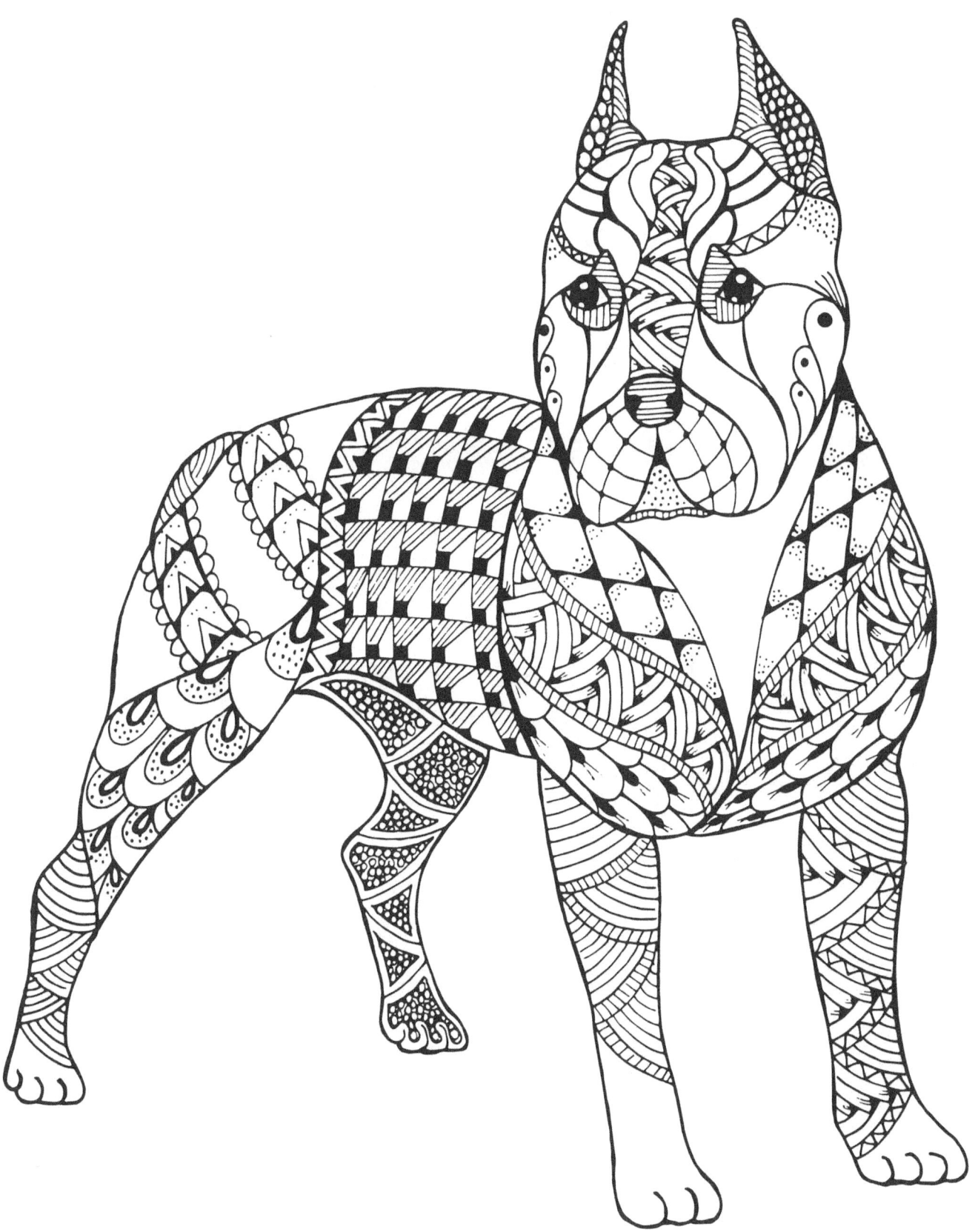

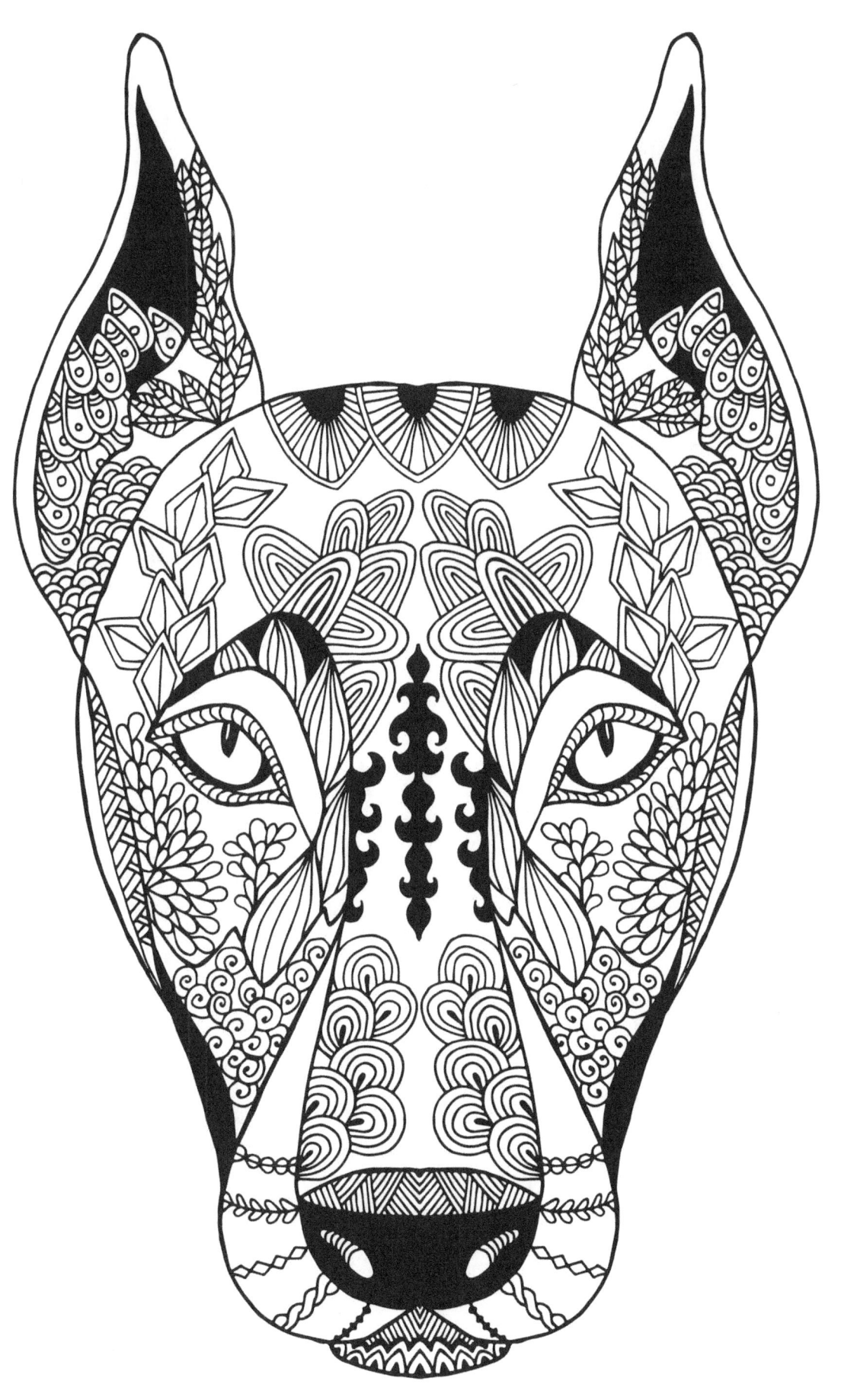

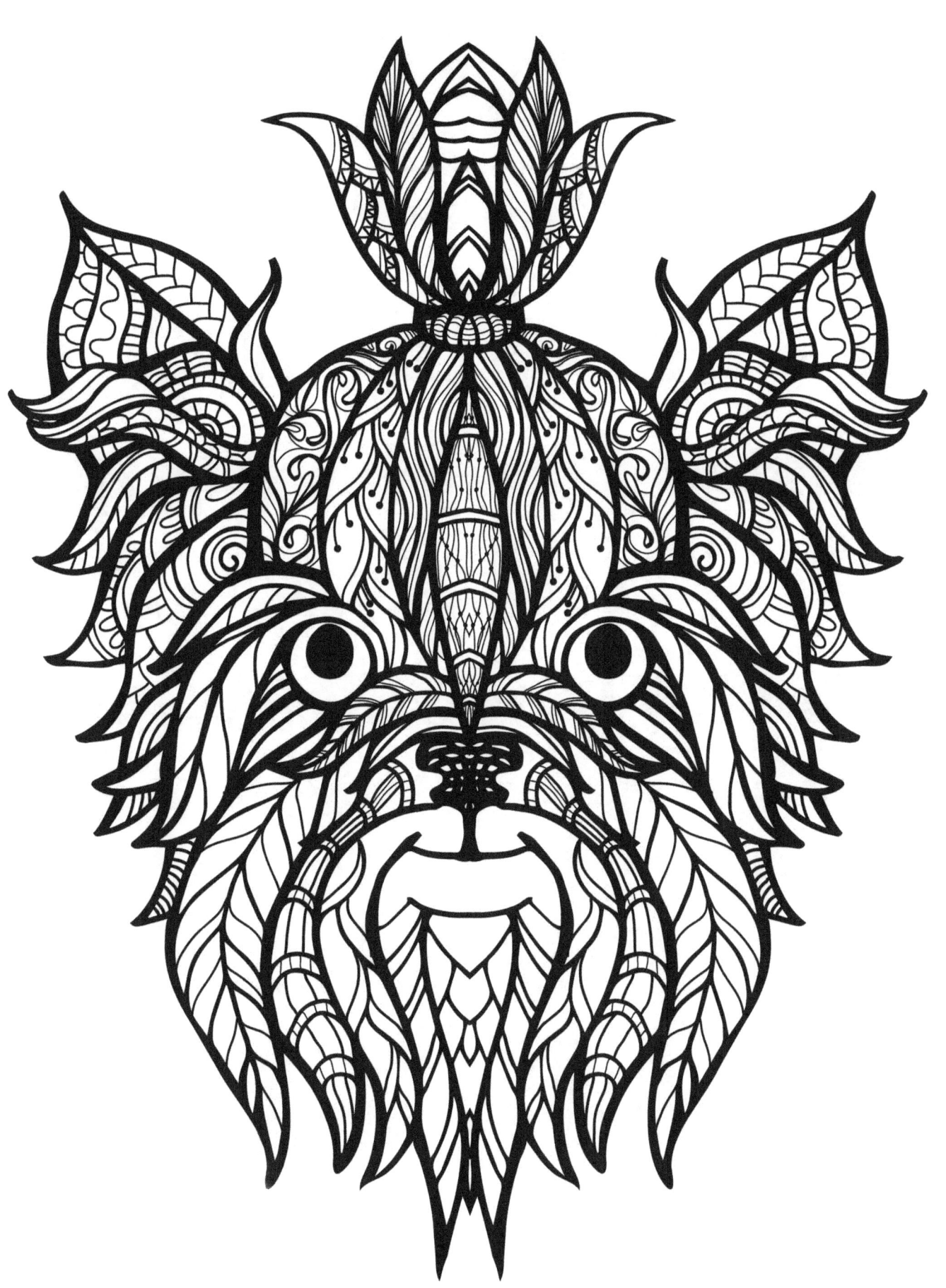

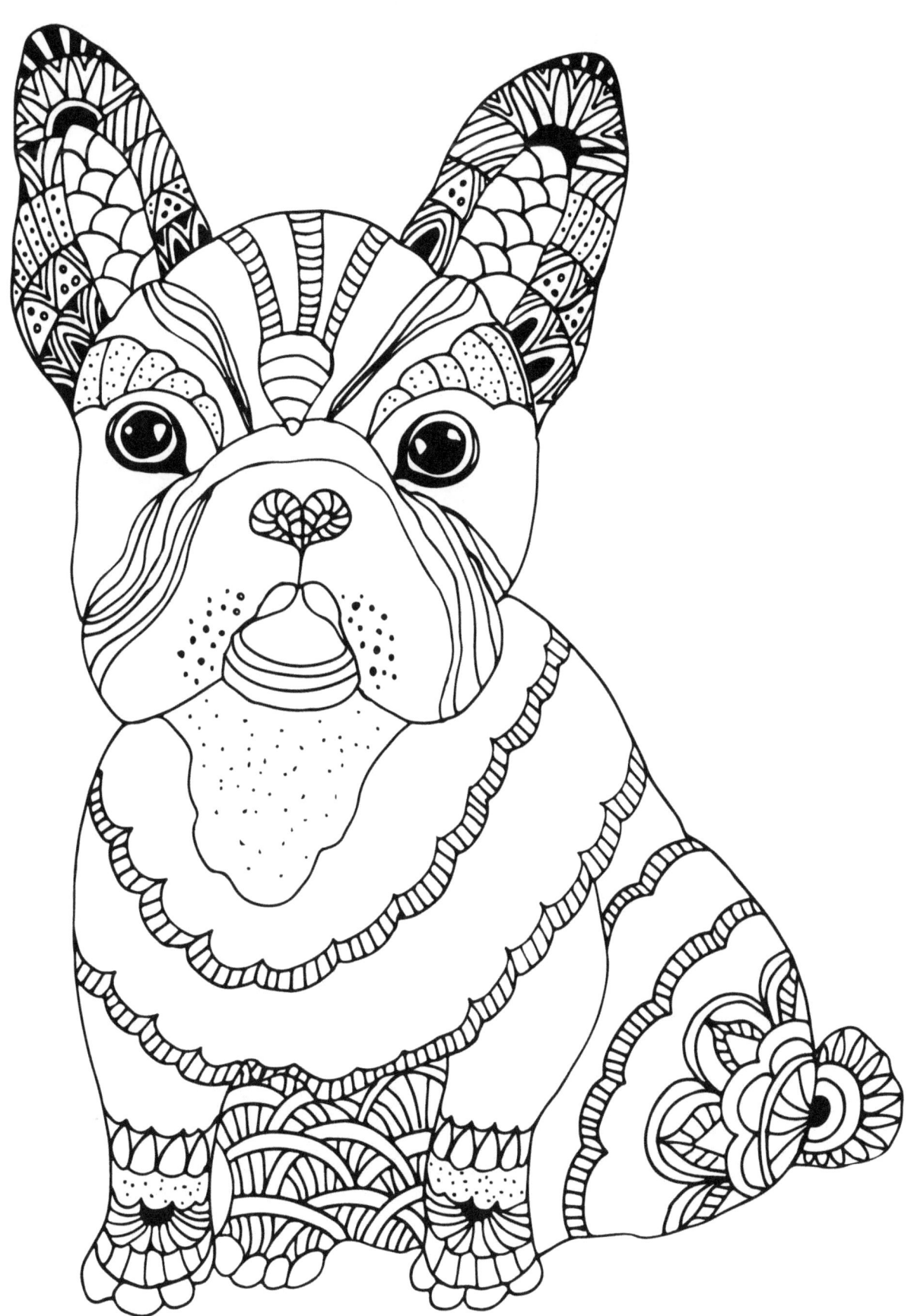

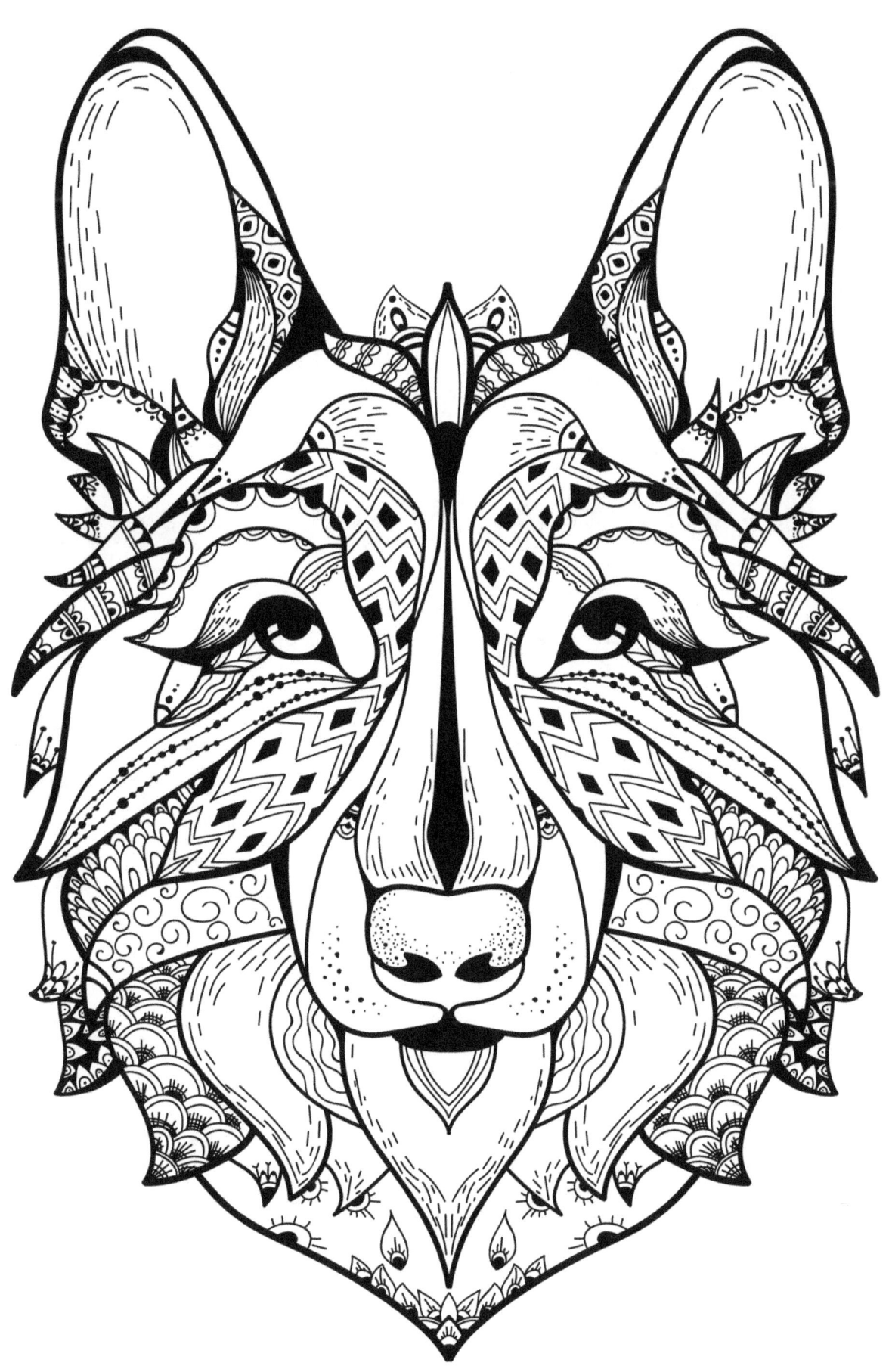

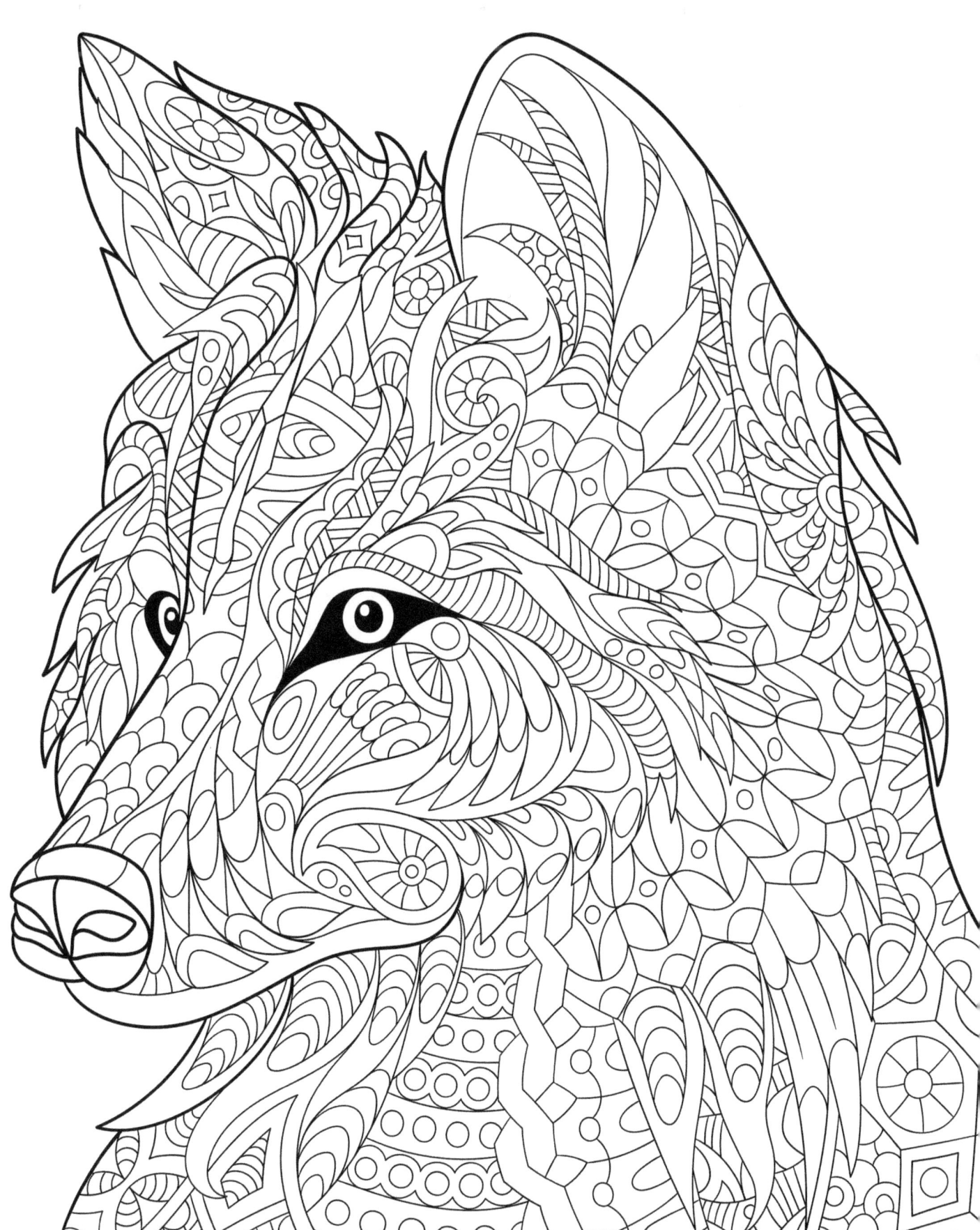

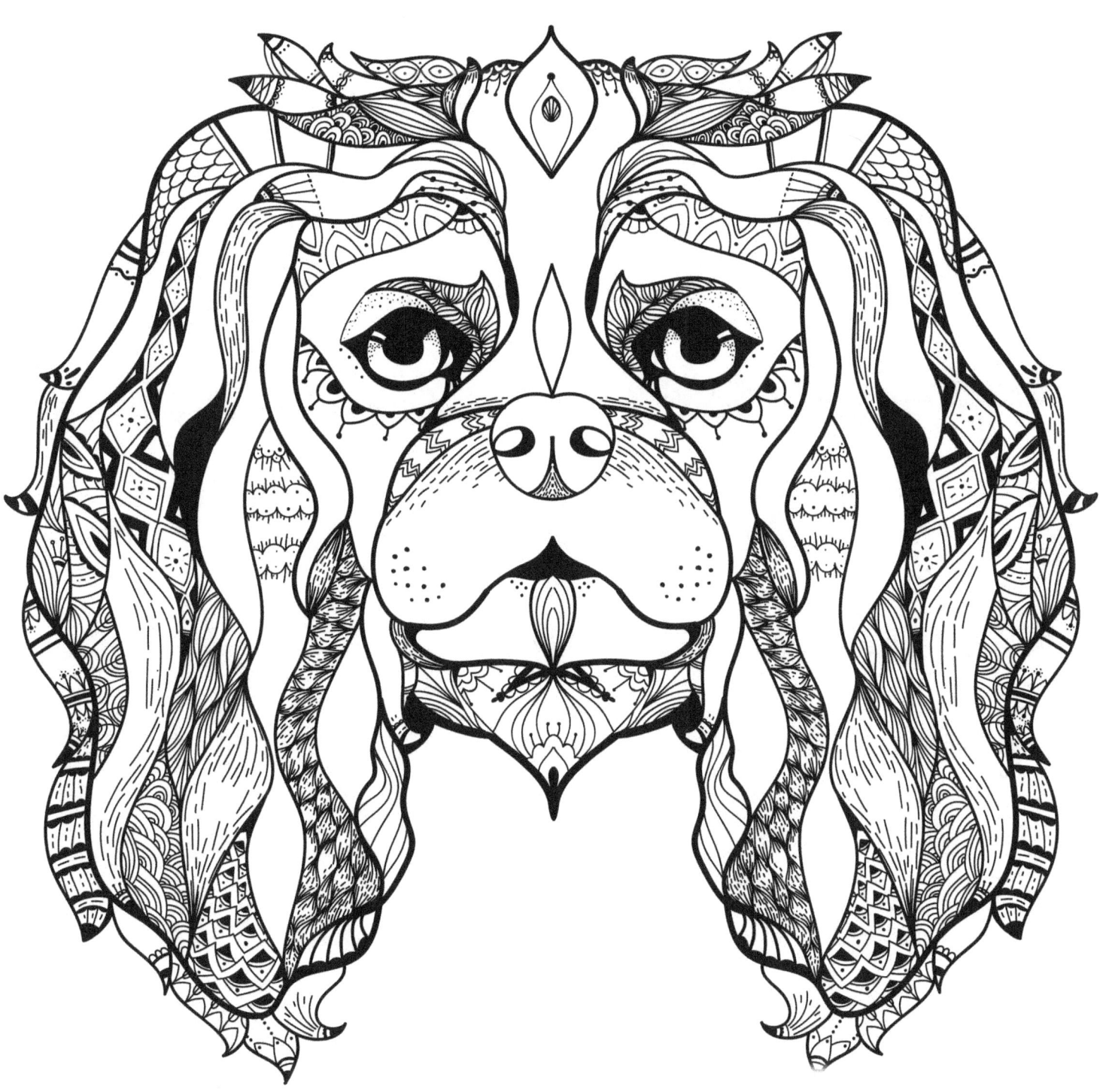

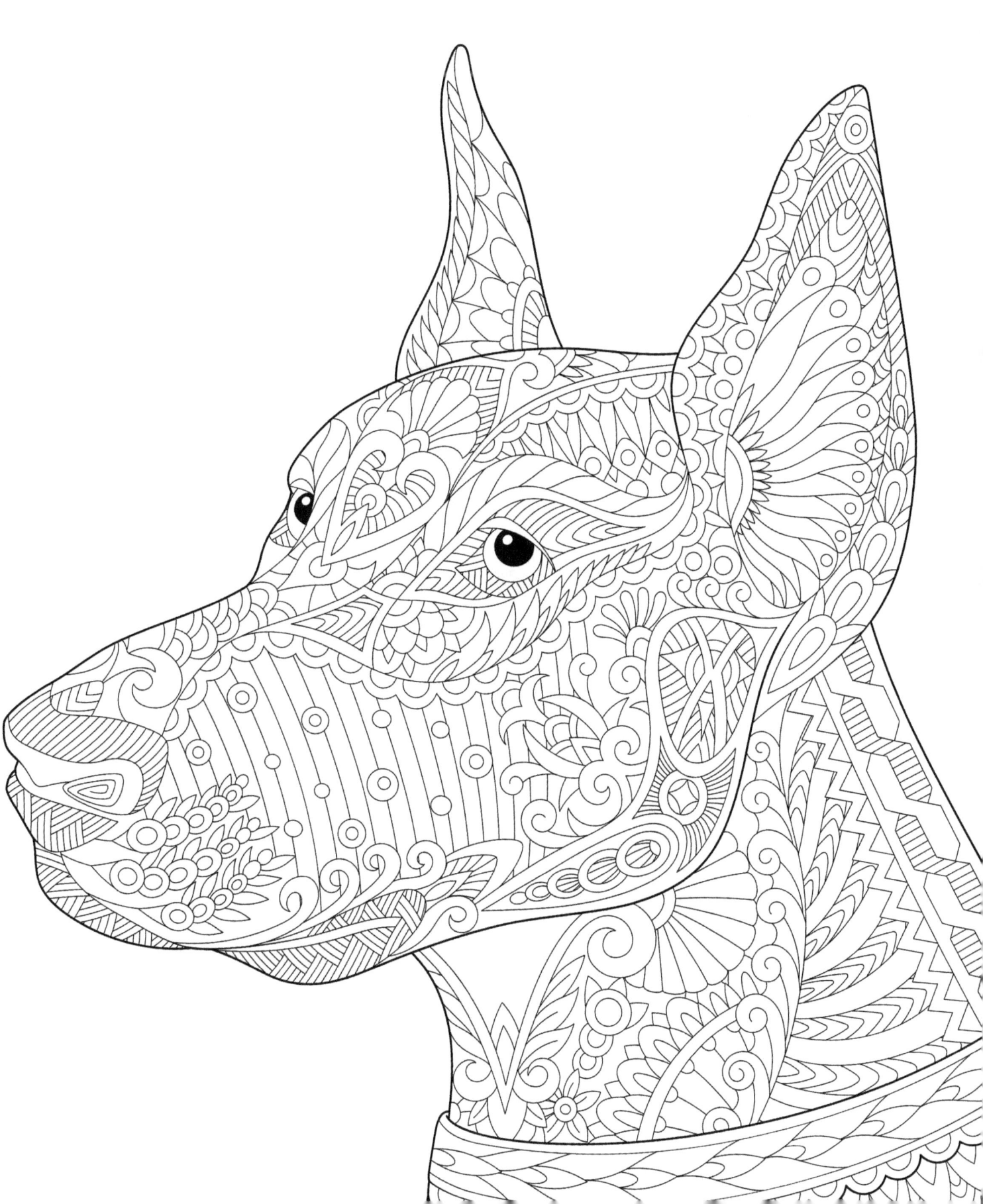

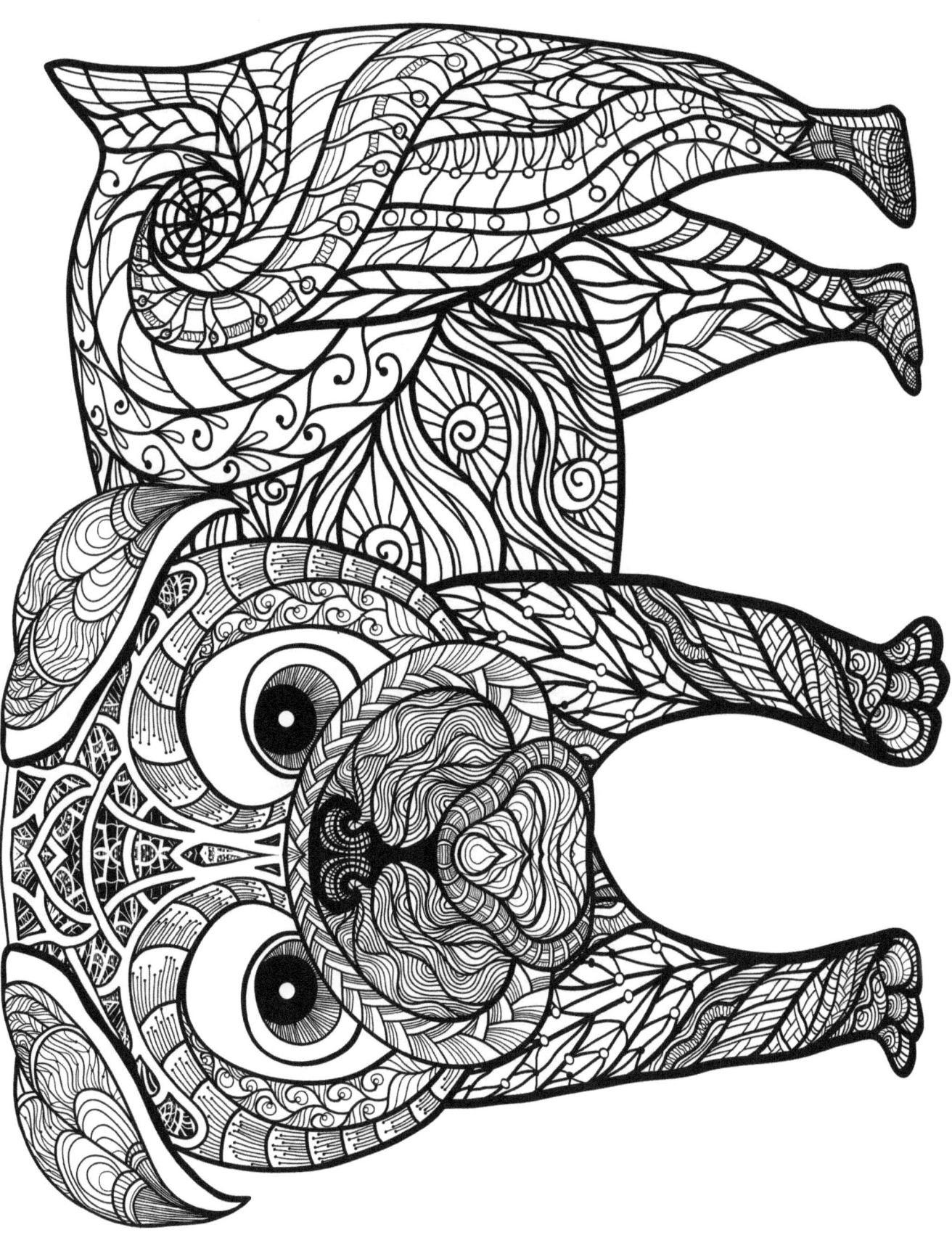

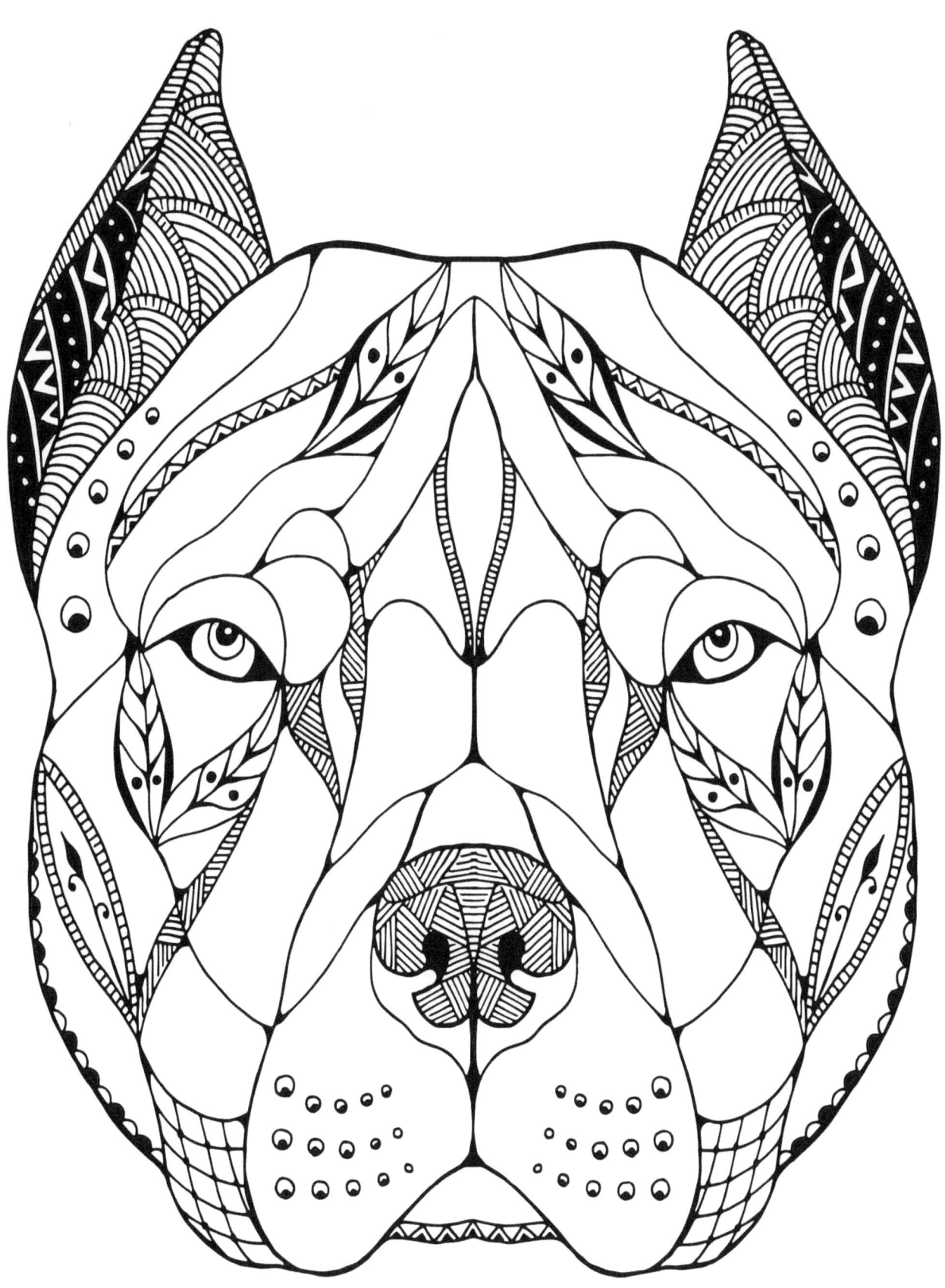

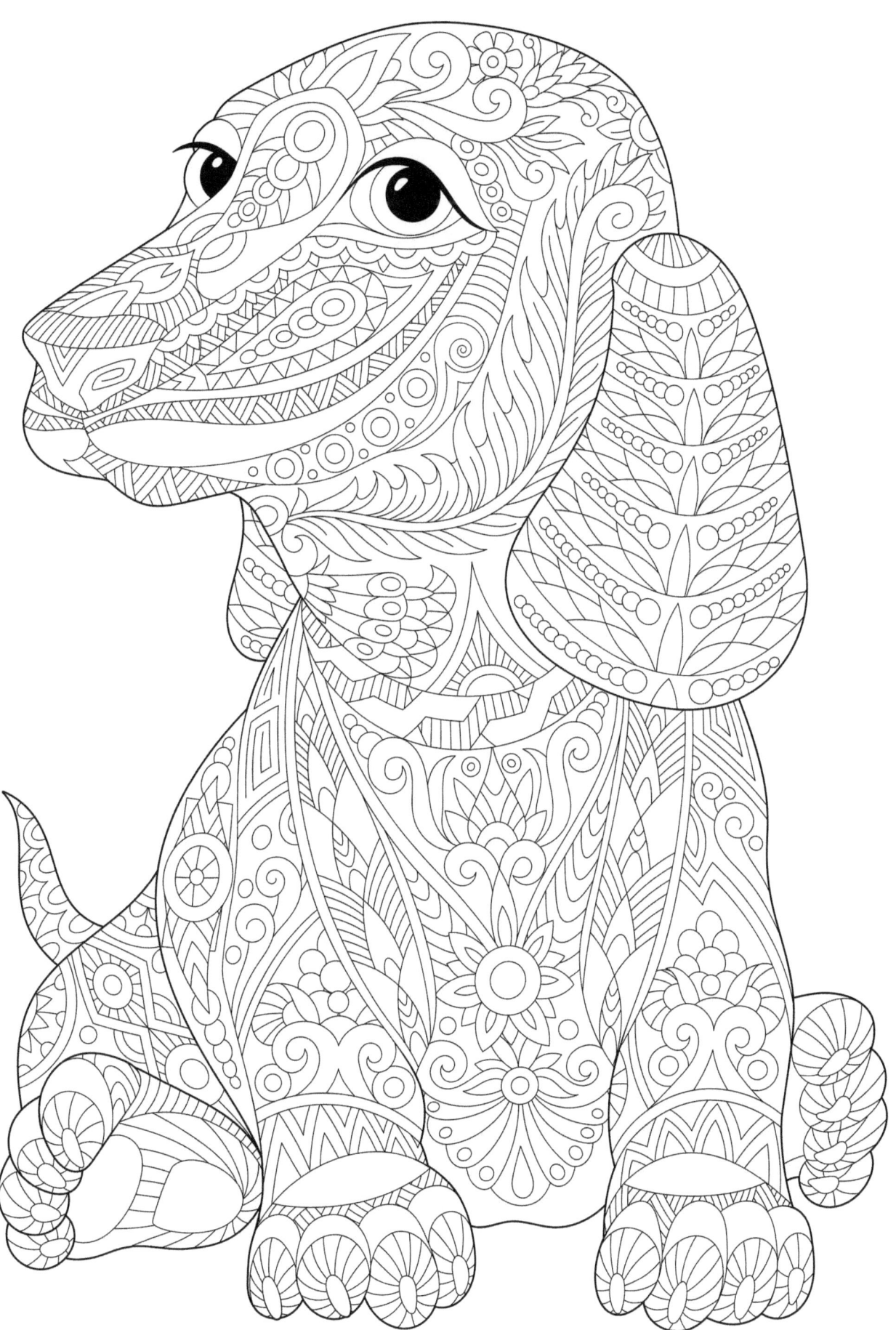

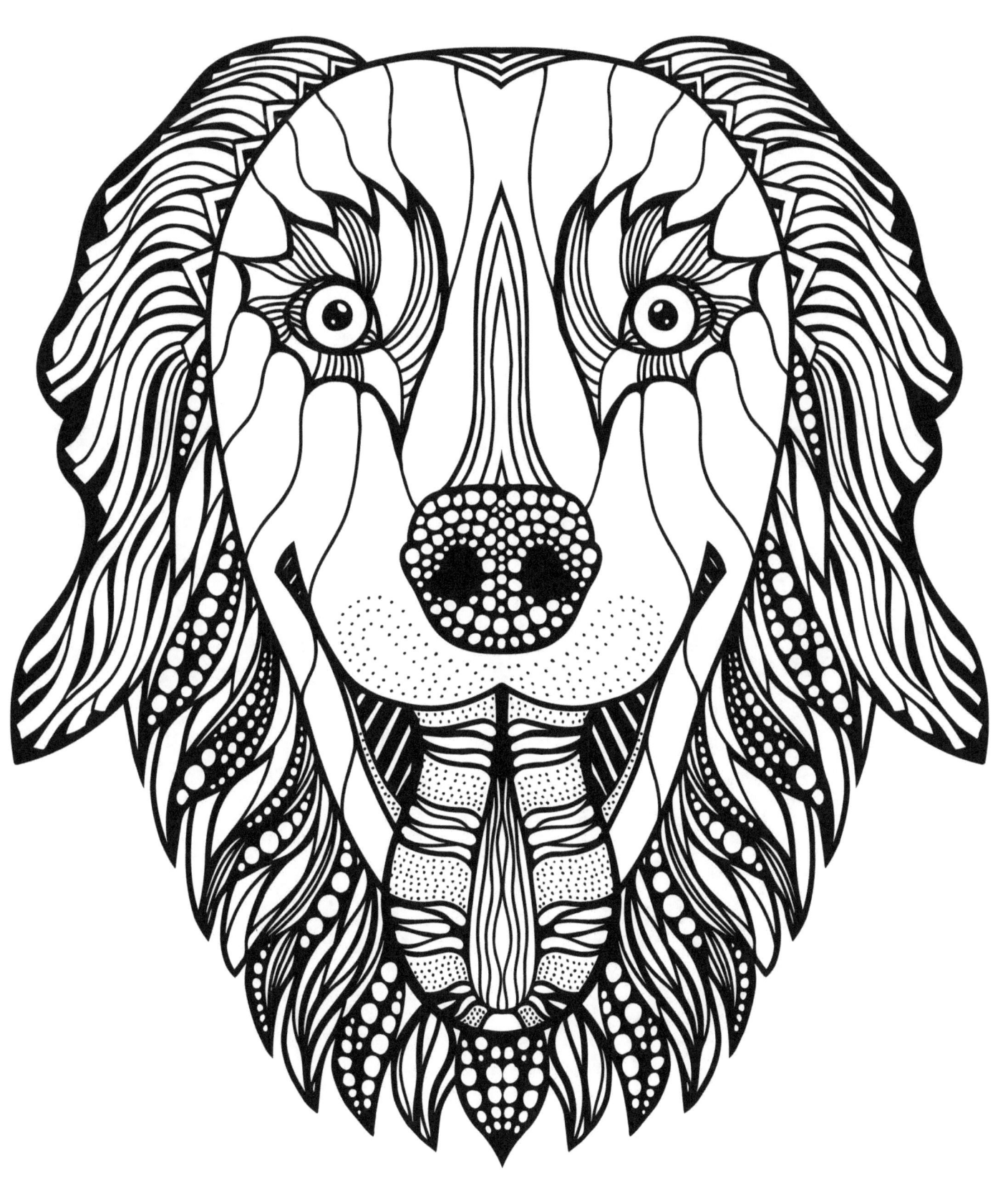

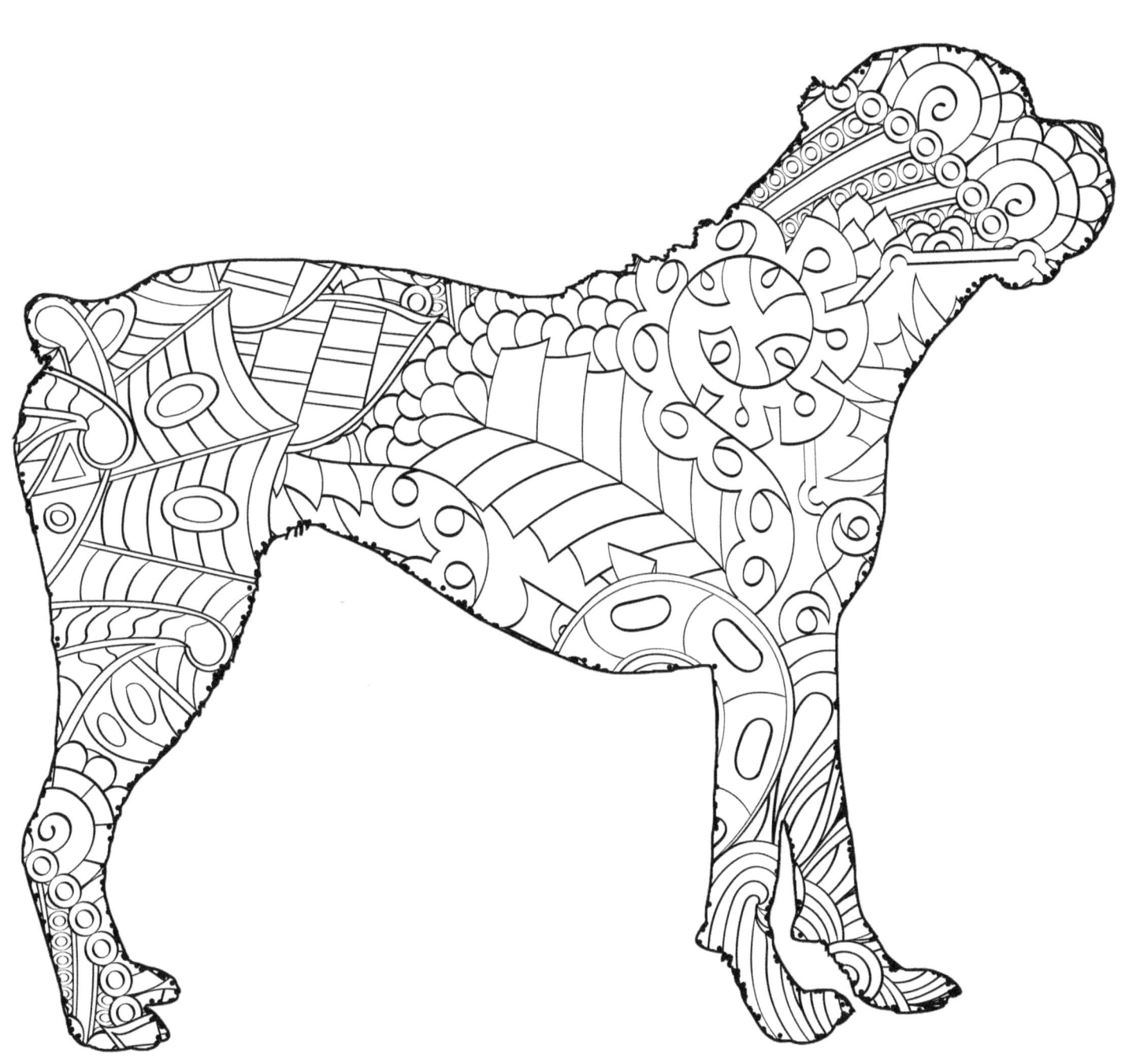

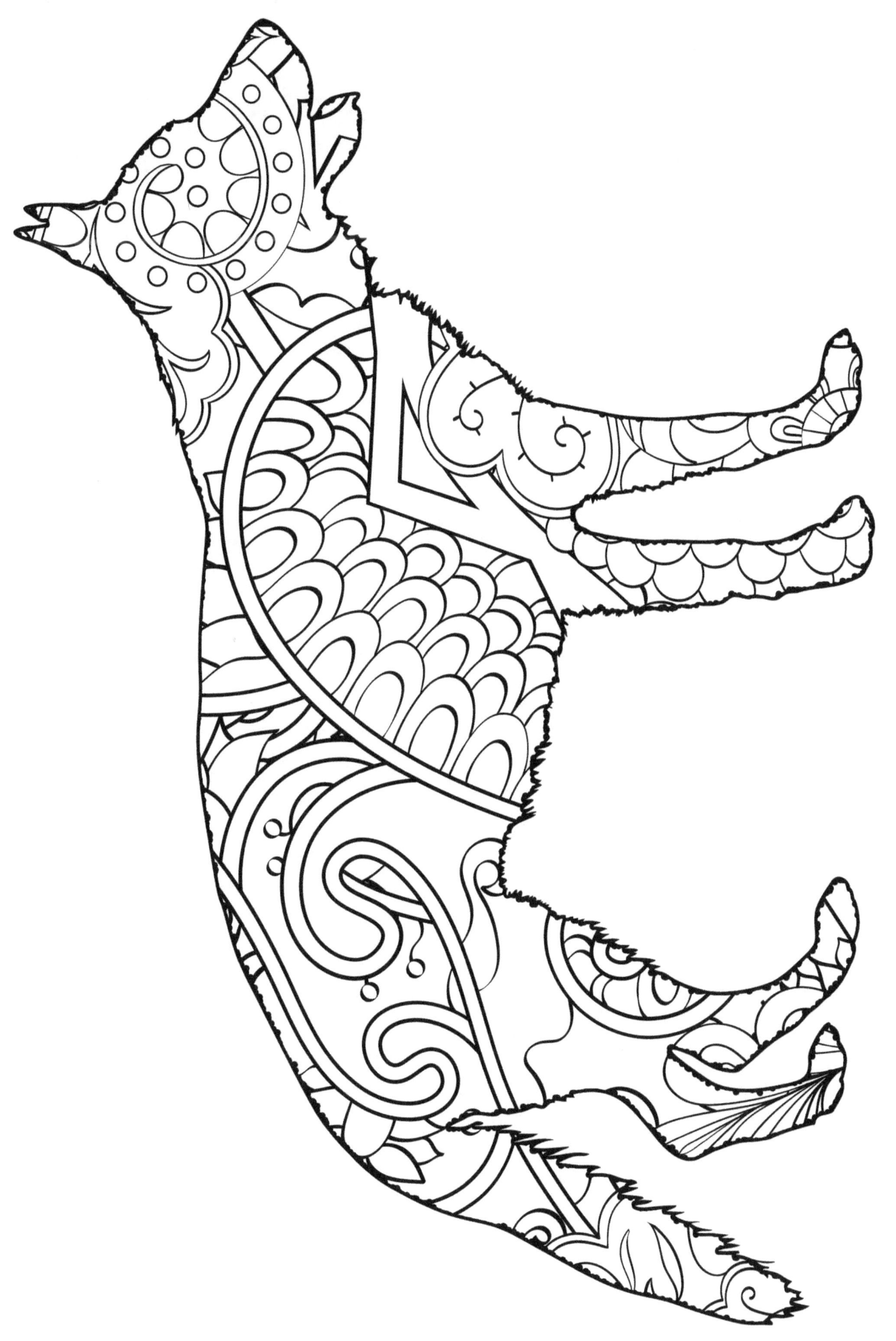

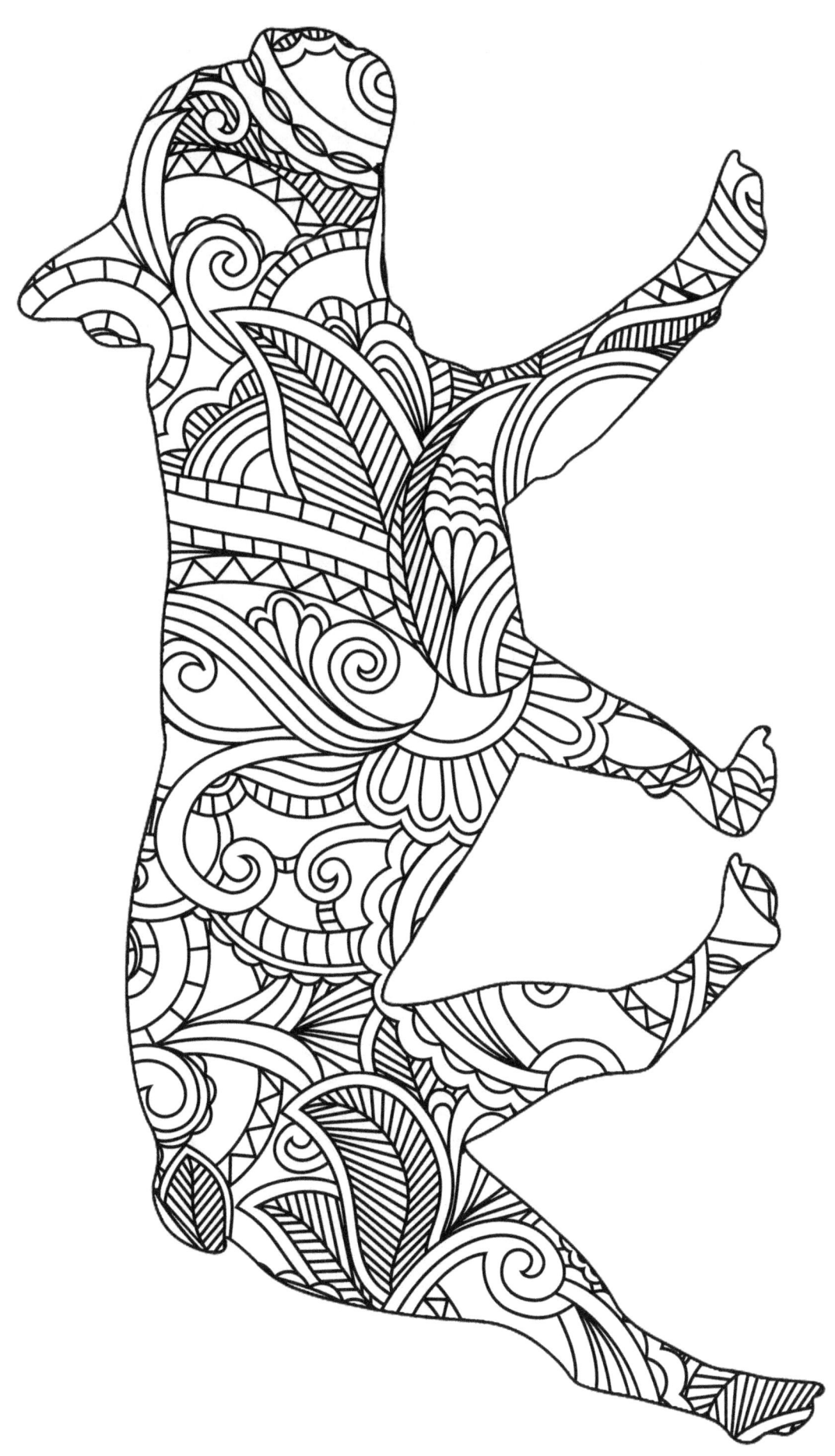

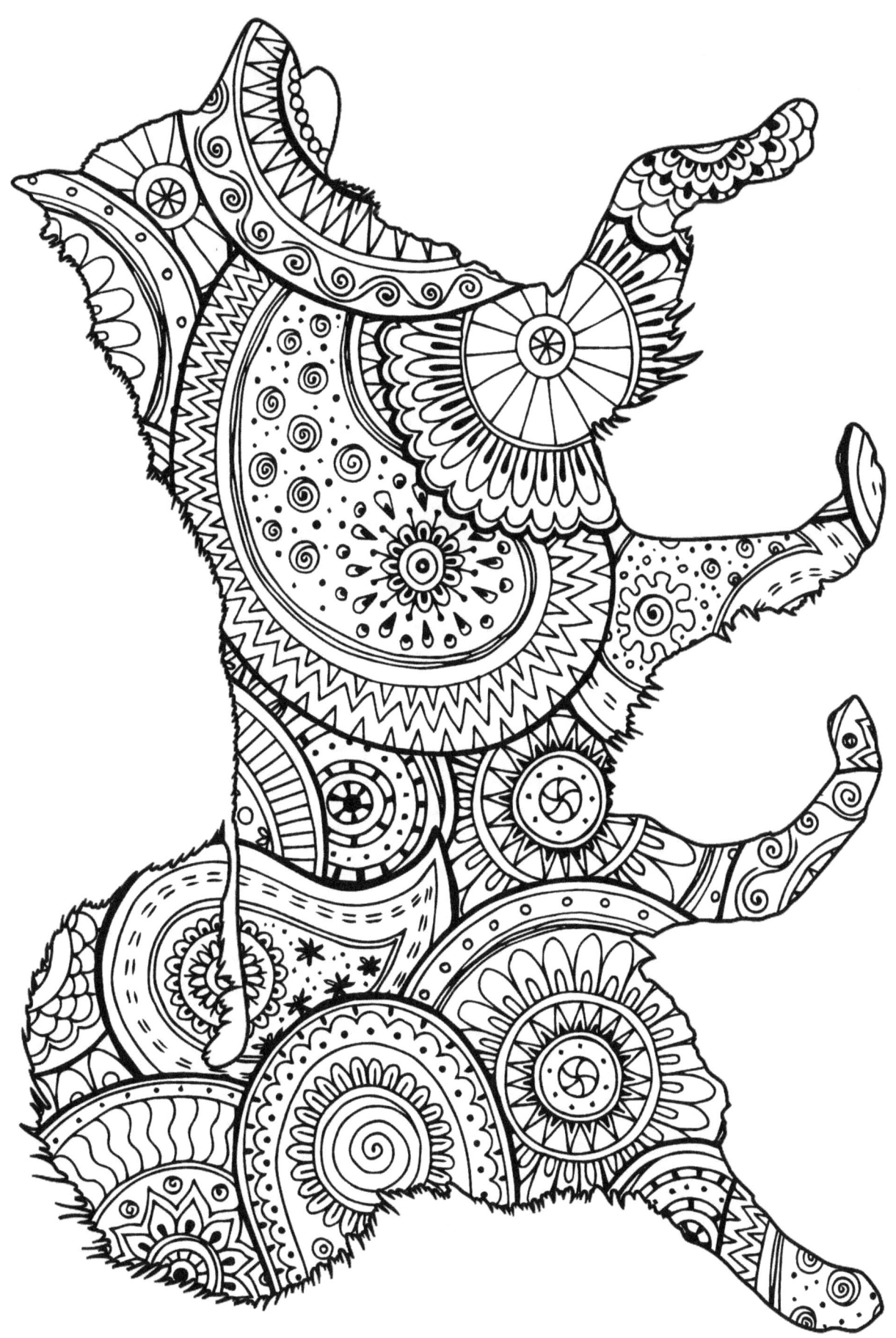

www.ingramcontent.com/pod-product-compliance
Lightning Source LLC
Chambersburg PA
CBHW080630190526
45169CB00009B/3342